Power Poems

Thunder From the South

by
Michael Dixon

authorHOUSE®

AuthorHouse™
1663 Liberty Drive, Suite 200
Bloomington, IN 47403
www.authorhouse.com
Phone: 1-800-839-8640

First published by AuthorHouse 10/19/2009

ISBN: 978-1-4389-1054-3 (sc)

Printed in the United States of America
Bloomington, Indiana

This book is printed on acid-free paper.

This book contains my life long journey in the search for knowledge. As a 1972 graduate of NCCU, I was privileged to have the best teachers in the world, for which I am so grateful. Thanks to Nette, Teenie, and Barbara for getting Claudia and I off to an early start in education. Thanks to my mother for giving birth to me and my grandmother for constantly encouraging me. This book is indeed "The Soul of M.D.

Thanks to God for the inspiration and motivation,

Dedicated to:

My parents, Louise Dixon and the late Haywood Dixon, and my grandparents, the late Leonard Sr., and Mabel Lyons

Special Dedication to my sister, the late Claudia Greene.

Acknowledgments:

Minister Louis Farrakhan (The Nation of Islam)
Dr. C. Eric Lincoln
My aunts, Mabel, Teenie, Nette, Barbara and Ruth
My uncles, Johnny Butler and Leonard Lyons, Jr.
The Birmingham Times (Bernadette Wiggins) of Birmingham, Alabama
James Brown Enterprises (Maria Moon) of Augusta, GA
My extended family
Barbara Poole (BJ's Business Services)
The Birmingham Times (Jesse Lewis and Carolyn Bolivar)
Bruce Bridges (The Know Book Store)
Cash Michaels (The Carolinian)
Malik and Tamera
My Boys from North Durham Q. Barbee, Maxie Davis, Junior, Dubois Cates, and the whole community.
Places in the heart - Porky, Christine, Aunt Helen, Aunt Christine, Uncle Jim, Uncle Alex, and my father, Haywood Dixon
Durham's "Godfather of Soul", my uncle, J.B. (Johnny Butler)
Thanks to Charlotte, Linda Jo, Paris, Rochelle, my sister Regina, Steve, Reggie and Rob, Boo

Butler, and everyone in the Durham Community.
James Brown Enterprises (Ms. Booker)
Kwame Toure'
Boys from NCCU - Joe Harrell, Bruce Holloway, "Candy" Holloway, Franklin Tate, Clifton
Herring, Roderick Hodges, B.B. and the rest of the crew.
Dr. Earlie Thorpe, Dr. Helen Edmonds, C. Jones.
Mt. Gilead Baptist Church
The entire Durham Community
North Carolina Central University
and
NCCU's History Department ('72 graduate)

CITY OF
ATLANTIC CITY

BARBARA HUDGINS
Council Member-At-Large

CITY HALL
ATLANTIC CITY, NJ 08401
609-347-5241

December 3, 1993

Mr. Michael Dixon
P.O. Box 11106
Durham, NC 27703

Dear Mike,

I have read your book of poetry from cover to cover and am extremely proud of your accomplishments. You are to be commended for the time, thought and effort that you put into creating such great pieces of work. Each one is like a tapestry woven into wondrous words descriptive only of the individual to whom it refers.

Continue to strive for excellence in your own quiet, reflective and productive way; the end result can only be success.

Good luck and my God continue to create beautiful poetry in your mind that you can share.

Sincerely,

BARBARA L. HUDGINS

BLH:eeb

CITY HALL
LOS ANGELES, CALIFORNIA 90012
(213) 485-3311

OFFICE OF THE MAYOR

TOM BRADLEY
MAYOR

February 16, 1993

Mr. Michael Dixon
P.O. Box 11103
Durham, North Carolina 27703

Dear Mr. Dixon:

Thank you for sending me copies of your poems. It was most thoughtful of you to take the time to share your poems with me, and I appreciate it very much.

Sincerely,

TOM BRADLEY
Mayor

TB:lcc

Minister Louis Farrakhan

NATIONAL REPRESENTATIVE OF THE HONORABLE ELIJAH MUHAMMAD
AND
THE NATION OF ISLAM

IN THE NAME OF ALLAH, THE BENEFICENT, THE MERCIFUL.
I BEAR WITNESS THAT THERE IS NO GOD BUT ALLAH AND I BEAR WITNESS
THAT MUHAMMAD IS HIS MESSENGER.

January 6, 1992

Michael Dixon
P.O. Box 11103
Durham, NC 27703

As-Salaam Alaikum (Peace Be Unto You)

Dear Brother Michael,

I pray that this letter will find you in the best of health and spirit.

Thank you for your recent letter. I certainly appreciate your taking the time to write and share creative your thoughts through poetry.

I want you to know that I am very honored by your poetic words.

As-Salaam Alaikum
Your Brother and Servant,

The Honorable Louis Farrakhan
Servant to the Lost Found
Nation of Islam in the West

HLF/lf

Table of Contents

Power Poems

Power Poems II

Power Poems

Portrait of a Great Man
Louis Farrakhan

Louis Walcott entered the **Nation of Islam** in **1955**
He was a happy go lucky kid with a lot of **jive.**
His impact was immediate and time would **tell**
When he had the whole Black Nation singing **"The White Man's Heaven is a Black Man's Hell".**
When **Malcolm X** went to **Boston University** and **Harvard, Louis** was at his **side**
Not like so many others who joined him after he **died.**
Malcolm loved him as a brother and this caused a lot of envy **among us**
Because as a people our history had shown that there were few leaders we could **trust**
This basic training with **Malcolm** gave **Minister Farrakhan** a great **foundation**
For his later endeavors when **Allah** would choose him to lead the **Nation.**
The **Honorable Elijah Muhammed** picked him as the National Spokesman for his **organization**
Because he needed a man who could face great adversity and still maintain his **dedication.**
In the 80's, **Minister Farrakhan** became the symbol of the **New Black Man**
The Man who wouldn't back down once he made his **stand.**
When the Media attacked Miss America **Venessa Williams** over unsavory **photographs, Minister Farrakhan** was the first leader to her **aid**
He defended her honor and dignity as a woman and now she tops the hit **parade.**
Minister Farrakhan we thank **Allah** for putting a great man like you on our **side**
Because of you all Black People now carry a tremendous sense of **pride.**

Consultant: Marc X Butler of Memphis TN, My cousin

Arthur Ashe

Coming out of Richmond, Virginia, **Arthur Ashe** made his **stand**
And showed that he was not only a great athlete but **"one hell of a man"**.
When **Arthur** entered the tennis world, he was all **alone**
He kept up the pressure until all **Jim Crow** laws were **gone.**
His **father** proved to be a great influence on his **life**
He showed him how to have dignity despite all the animosity and **strife.**
Durham's legendary coach, **Carl Easterling,** was **Arthur's** early **teacher**
He developed young players like **Arthur and John Lucas** with the
style of a **preacher.**
Arthur was the first **Black** man on the **Davis Cup Team** and to win at
Wimbleton too
Although the accomplishments were great, **Arthur** realized there were
more important things to **do.**
The game of life proved to be **Arthur's** great **call**
Because he realized that one man's athletic achievements didn't matter
that much at **all.**
God was his guide through his fights for all the world's **oppressed**
He decided as a human being, he would be negligent if he didn't give
his **best**
Arthur was an early and effective opponent of **South African Apartheid**
His efforts rallied a whole world to his **side.**
Arthur's tireless efforts in tennis and human rights led to his heart **attack**
But being the fighter that he was he didn't allow this to hold him **back.**
Nelson Mandela felt that **Arthur** was his **friend**
So it was fitting that **Arthur** was the first **American** he wanted to see
at his jail term's **end.**
A faulty blood transfusion made **Arthur** contact **AIDS**
So he found a new cause in his human rights **crusade.**
Thank you **Arthur** for making us so **proud**
Because your name will be forever in the **clouds.**

Dedicated to the late Carl Easterling (Bear) Hillside High School's
Basketball and Tennis Coach.

Published in "The Birmingham Times" 6/10/93

Curtis

Curtis Mayfield (Singer, Songwriter)

*You entered our lives with a voice in the **clouds***
*You made us all "so very **proud.**"*
*With **Jerry Butler** you blended like a hand to a **glove***
*You told us all about "**Your Precious Love**".*
Chess** records wanted only **Jerry Butler** after the recording **session
They made a monumental mistake by neglecting you and the rest of the
Impressions.
*Years before you told us about a "**Dead Freddy**"*
*You told us all about the coming of **God** so "**People Get Ready**".*
*You told us about something worth more than **gold***
*It was your ideal lady "**The Woman with Soul**"*
*With "**Miss Black America**" you gave tribute to all **Black Queens***
*Your songwriting brought class to our struggle instead of trying to be **mean.***
*While with the **Impressions** you gave lessons in how to treat our special*
*black **pearl***
*When you went solo you showed your international focus with "**Back to***
*the World**".*
*You started your **own company** and went straight to the **sky***
*With the release of your greatest album "**Superfly**".*
Racism** in the **Academy** denied you your **due
*Because **Isaac Hayes** had won the Year before and they didn't want to*
*honor **you.***
*"**Claudine**" was your next project where you had **Gladys Knight** going*
*"**On and On**"*
*You came back producing the **Staples Singers** "**Let's Do It Again**" when*
*everyone thought you were long **gone.***
*Again, with the movie "**Sparkle**" you filled the **bill***
*When you had the young ladies singing "**Giving him Something He Can***
*Feel**".*
*May **God's** blessings be with you in these trouble **days***
*Because **Curtis** you showed all of us that "**we are winners**" In so many **ways.***

Dedicated to: my sisters, Claudia Ann, Regina Gail
and my aunts Mable Butler, Barbara Hudgins

Ernestine Lyon, and Juanetta Alexander
Special dedication to My Grandmother, Mabel Lyon
and my mother, Louise Dixon

Published in "The Birmingham Times" 8/12/93

J. B.
(James Brown, "Godfather of Soul")

When you wanted to be funky and get **down**
All you had to do was play anything by **James Brown.**
Coming out of Augusta, GA., J. B. was **"Out of Sight"**
He lived up to his name **"Mr. Dynamite".**
Starting out on **Little Richard's Show, Brown** decided not to be anyone's **flunky**
So he showed us all how to **"Make it Funky".**
He told all the women remember not to **nag**
Because your **"Old Papa's Got A Brand New Bag".**
With the **Famous Flames, J. B.** was the music world's man of the **hour,**
He made his life and career the true example of **"Soul Power".**
J. B.'s business acumen showed that he was nobody's **fool**
He endeared himself to the public by urging kids to **"Stay in School."**
When it looked like **J. B.** had his head in the **clouds**
He reminded us all to **"Say It Loud, I'm Black and I'm Proud."**
Jealousy and the envy in official circles landed **J. B.** in **jail**
But the story of **J. B.'s** Music was only beginning to **jell.**
The rappers brought **J. B.'s** music to a new **generation**
And youths began dancing to the music of **J. B.** throughout the **nation.**
Maceo, Bobby Byrd, and Fred Wesley became popular with rappers of **today**
But everyone wanted to find out about the **Godfather** who showed them the **way.**
The Godfather is back and is still **"Out of Sight"**
And his **Godchildren,** like **Hammer,** are doing it up **right.**
Thank you **Godfather** for being awake while others chose to **nap**
Because you told us the future in your 60's song **"Brother Rap."**

Published in "The Birmingham Times" 7-13-93

5

Alex Haley

To bring **Black History** to life is the mission to which he was **born**
So in his death we must rejoice his life and not **mourn.**
Little did **Kunta Kinte** know that his coming to America in the hole
of a slave **ship**
Would result in his descendant taking all of America back on the
return **trip.**
This man, **Alex Haley** started his career as a mess boy in the **Coast
Guard**
But his penmanship and intelligence impressed all the men of his **squad.**
He was promoted to chief journalist and he was on his **way**
To bring to **Black People** a new and brighter **day.**
He embarked as a writer in what would be history's pivotal **move**
His first article **"Mr. Muhammed Speaks"** testified that Haley was in
his own special **groove.**
Along with his friends **Dr. C. Eric Lincoln and Louis Lomax,** he
brought the **Nation of Islam** to the **mainstream**
Among writers he was considered the **cream.**
"The Autobiography of Malcolm X" was originally to be a book on
the **Honorable Elijah Muhammed's life** and **preachings**
But the **Messenger** being a humble man told **Haley** to do it on
Malcolm to show the effects of his **teachings.**
His association with **Malcolm** and the **Messenger** provided **Haley**
with the **inspiration**
To complete the journey that **Kunta Kinte** ordained when he entered
this **Nation**
"Roots" was the work that made slavery personal to all of **America**
It drove millions of **Blacks** into a state of **hysteria.**
"Roots" was done with an abundance of **feeling**
Haley used it to promote multiracial **healing.**
Alex Haley will always be remembered as **God's** goodwill ambassador
to the world and **Nation**
But among **Black People** he will be remembered for his example of
strength and **determination.**

Brother Wali
(Abdul Wali Muhammed, former editor of "The Final Call")

You seemed so familiar even though we had just **met**
I guess it came from years of reading your father's columns in weekly
issues of **Jet.**
You wanted to be **Ivy League** so you went to **Cornell**
But your interest waned when you saw black people catching **hell.**
You joined the **Nation** and your interest in the plight of the blacks
expanded
Your joining the **Final Call** staff assured success because the
Journalistic Eagle had **landed.**
You provided fuel for the **Nation** at a critical **time**
You gave much needed nourishment for the modern **black mind.**
You kept us abreast of the **Nation's** every **move**
The people who read the **Final Call** were always in the **groove.**
You provided space for great black writers of **today**
You opened the **Final Call** up to what world leaders had to **say.**
You raised the name of the **Honorable Elijah Muhammed** on a
pedestal where **it** should **be**
You made **Minister Farrakhan** a success for all the people to **see.**
Your travels to **Africa** brought us blacks together as **one**
You brought forth **truth** and had falsehood on the **run.**
You brought new cures from **Africa** on the dreaded **AIDS plague**
You brought insight on disease that the government has been officially
vague.
Thank you **Brother Wali** for your brilliant service to **The Nation**
You'll always be remembered because you left a solid **foundation.**

Floyd Mckissick

(This is dedicated to that great warrior for Blacks **Floyd McKissick**)

A great black man who had a law **degree**
Who could not be satisfied until all blacks were **free.**
He had a fire within him that kept him on the **go**
No matter how hard he tried he wasn't satisfied with the **status quo.**
Floyd lived in the furnace and couldn't go to Atlanta for **rest**
He gave all he had for **Black People** so he could pass **God's test.**
He used his own children as guinea pigs to integrate N.C. **schools**
He believed like **King** that we'll all live as brothers or perish as **fools.**
In Durham and Greensboro he led the movement for equal public
accommodation
They served as a model for **Blacks** throughout the **Nation.**
The accomplishments in Durham opened up the **door**
and set the stage for the **Civil Rights Bill of 1964.**
When the sit-ins in Greensboro started, the students wanted to make
it **stick**
So a long distance call was made to **Floyd McKissick.**
He went to Greensboro and showed them the **way**
So the sit-ins went on day after **day.**
With **Floyd, Black Power** was not just a slogan but a program to be
acted **upon**
With his nature and temperament he put himself under the **gun.**
The **Artists against Apartheid** said "**Sun City** they were never going
to **play**"
But these Artists never gave Soul City a chance to see the light of **day.**
Things said about **Floyd** when he left the **Democrats** to go
Republican were not very **kind**
Most **Black People** in America concluded that he had lost his **mind.**
Malcolm had said that the basis of Freedom is **land**
So **Floyd** wanted Freedom so bad he went with Nixon's "**bird in the
hand.**"
Soul City was the fulfillment of a century old **goal**
But instead of us uniting and contributing we sat back and watched it
fold.

Being taken for granted by the Democrats was something **Floyd** couldn't **take**

So he told the Democratic Party they could all go jump in a **lake.**

In **Civil Rights** it was **Floyd** who set the **stage**

To make sure that all of us were involved at an early **age**

So history could record another **page.**

Though you were with us for a season it seems as only for a **day.**

But like Frank Sinatra you did it your **way.**

Dedicated to my mother Lou and my sister Claudia Ann

John Lucas Jr.
(Basketball Star)

John Lucas Jr. gave his parents a lot of joy when he entered the **world**
He had been preceded by an older sister **Cheryl. John** was special even
as a **child**
He had such a gregarious nature that drove people **wild.**
Coach Easterling (Bear) took him under his wing and treated him like
a **son**
The odyssey of **John Lucas** had just **begun.**
Bear greeted **John's** natural ability with great **elation**
And through his tutelage made **John** the greatest junior tennis player
in the **nation.**
Being around **John** was such a **Joy**
That **Bear** made him Hillside's basketball teams **ballboy.**
Hillside's Legendary "Goat" Bullock(N.C.'s greatest High School
player) took him under his **wing**
and showed him the true joy that basketball could **bring.**
John went on to become a **high school All-American in Basketball
and Tennis too**
He showed that in sports there was nothing he couldn't **do.**
He went on to **Maryland** and showed his abilities to the **nation**
He continued in basketball and tennis to show his All-American
domination.
The **NBA** made **John** it's top pick in **1976**
His ballhandling skills made him a integral part of the **Houston
Rockets** team **mix.**
Despite his Athletic prowess, **John** found it difficult to conquer the
child inside the **man**
Because in life it seemed as if everything had been dumped in his **hand.**
During the off seasons **John** became part of the pro tennis **tour**
He tried so hard to fight the powerful drug **lure.**
Lucas played with several teams during his long basketball **career**
But his unhappiness over the adulation & fame was also **clear.**
Drugs provided the escape that **John desired**
Because the restraints of being **"John Lucas, sports star"** seemed to
have his life **mired.**

God let **John** lose himself so he could find **others**
And show them through his treatment clinics that he was indeed their **brother.**
John was brought in to coach a dying **team (San Antonio Spurs)**
His guys immediately felt his impact by going on a winning streak
with that familiar **Lucas gleam.**
The **NBA** was introduced to the **legendary Hillside fast break**
Because he learned from **Bear and Coach Willie Bradshaw** the
sacrifices winning **takes.**
Coaching the **Miami Tropics & the San Antonio Spurs** shows **Lucas**
at his **best**
Because his inspiration & leadership shows that he has passed **God's test.**

Dedicated to:
Mr. and Mrs. John Lucas, Sr.
The "Late" Carl Easterling & Martha Easterling
Inspiration: Maria Davis
Special Dedication:
Mr. Johnny Butler & The late Howard McAllister, Sr.

The Honorable Elijah Muhammed
(Messenger of Allah)

Allah sent the Honorable Elijah Muhammed to America to redeem us
To save us from a life of sin in a land full of lust.
Muhammed showed us that self improvement is the only way
For us to make a newer and brighter day.
Malcolm, Farrakhan and countless others were raised by this man
In addition to consciousness, he taught that the basis of freedom is land.
With Allah as his guide, he conquered all obstacles in his way
He made white America respect what a Black man had to say.
Coming out of Sandersonville, Georgia, Elijah made it to Detroit
Because he was determined not to be just another Nigger for whites to
exploit.
Working in Detroit, he made the acquaintance.of W.D. Fard
Elijah, not being a foolish man, realized immediately he was in the
presence of God.
Fard taught Elijah the natural religion for the Black man
And also how to do for self in order to make your stand.
With the departure of Fard, Elijah had to go on the run
Because he was determined to free a people forever under the gun.
Under an arrest order signed by President Roosevelt, Elijah was sent
to jail
Because he refused to fight for the continuation of the Black Man's Hell.
Elijah emerged from prison to rebuild his Nation
So he could restore the Black man to his proper station.
Allah was Elijah's guide in all of his decisions
He even picked for Elijah a great leader from one of America's prisons.
Malcolm X emerged from prison as Elijah's Spiritual Son
And he, this time, put the white man under the gun.
Elijah raised, a dead Malcolm to the top of the Black liberation fight
Together they conquered all obstacles in sight.
Elijah started Black businesses on a nation wide scale
To help the black man escape his psychological shell.
Jealousy and envy drove Malcolm and Elijah apart
But they always remained together in each other's heart.

With new leaders like **Minister Farrakhan,** the **Nation** continues to
strive
And the world now recognizes that with the coming of **The
Honorable Elijah Muhammed,** our **Savior** had **arrived.**

(Dedicated to my grandfather, the late Leonard Lyons, Sr.)

Black Moses
(Isaac Hayes)

On the **Stax Label** out of **Memphis, Hayes** decided to make his **stand**
As the Co-originator of **Sam and Dave's** monster hit **"Soul Man"**.
On piano, **Hayes** became the integral part of the **stax house** band,
Booker T and the M.G.'s
Their music was always aimed to **please.**
In spite of his writing sucess, **Hayes** had a burning desire to **sing**
So with the album, **Introducing Isaac Hayes,** he throw his hat into
the musical **ring.**
The album was a flop, but it set the **mold**
For **Hayes'** next endeavor, **"Hot Buttered Soul".**
"By the time I get to Phoenix" would highlight the new musical form
of **"rap"**
It would be years later before anyone would attempt to fill the musical
gap.
His music told how fickle relationships could **be**
When he told of **"One Big Unhappy Family"** for all the world to **see.**
He told us all how hard it is to **lose**
When for the love of **John's girl** he **"Stood Accused".**
As **"Black Moses",** he told us for his baby's love he would **die**
Because in spite of everything he **"Never could Say Goodbye".**
Just when he had all of us hanging on love's **raft**
He changed his musical focus with his **Academy Award** winning score
"Shaft".
Personal problems and bad investments brought **"Black Moses" down**
But the impact of his music will always be **around.**
"Black Moses", you put the **"S"** in Soul
When it comes to love you are definitely the **mold.**

Dedicated to my father, **Haywood Dixon**

Malcolm X
(A Reflection)

*Macolm Little was born in the **Nebraska** capital, **Omaha***
*His sojourn on this earth would take him very **far.***
*His father, the **Rev. Earl Little** was a **Garveyite***
*Because he wanted to lead **Black** people into the **light.***
*Malcolm in his early years was considered a **thief***
*This would cause his mother a lot of **grief.***
*Living in a detention home, **Malcolm** became a star pupil in Junior High*
School
*But his desire to become a lawyer made his teacher call him a **fool.***
*As a teenager living with his sister **Ella** in **Boston, Malcolm** became a man*
*about **town***
*He showed that as a hustler he could really get **down.***
*He later became a pullman porter on the **railroad***
*So he saw firsthand the **Black man's load.***
*Becoming a hustler in **Harlem** he proved to be one of the **best***
*This would prove invaluable in his later attempts to clean up the **American***
mess.
*His life as a hustler eventually landed him in **jail***
*His stay there qualified him later to talk about the **Black man's Hell.***
God** came to **Malcolm** when he was in a prison **cell
*And he would emerge as **Elijah Muhammed's** spokesman, a man with a*
*story to **tell.***
*His influence would extend through his and future **generations***
As he, through his eloquence, attempted to restore the black man to his
*proper **station.***
*The greatness of man is sometimes measured by **time***
*Now some 30 years later **Malcolm's** message still blows the **mind.***
*For most black people **Malcolm's** message took years to **digest***
*But the relevance of the message showed that among **God's** leaders, he was*
*one of the **best.***

God is The Answer

*As we go through life totally **confused***
*With that everlasting feeling of being constantly **used.***
God is the answer
*When thoughts of grandeur fly flush in your **face***
*When you have a love that's hard to **erase.***
God is the answer
God** comes to us in our time of **need
*So, it's his word that all should **heed.***
*When your magnitude of problems seem to never **end***
*When an illness you have seems to never **mend.***
God is the answer
God is the answer** to all our problems **today
*Because **He's** always there in every **way.***

Dedicated to my grandmother (Mrs. Mabel Lyons)

Published in "The Birmingham Times" 4-8-93

Jesse
(Jesse L. Jackson)

Jesse Jackson entered this world shrouded in **mystery**
His mission in time would change the course of world **history.**
Though he was conceived by a mother who was not **wed**
It is no secret that **God** was in the conceptual **bed.**
His mother was persecuted by so-called **Christians** because they thought she was **wrong**
They in their small minds, didn't realize she was doing **God's** will all **along.**
Jesse, being a brilliant student, presided over the student body at **A&T**
His work in the movement gave only a small glimmer of the man he would **be.**
Jesse's friendship and association with **Martin Luther King** at the time of **his assassination,**
Produced jealousy and envy from his peers throughout the **nation.**
Presiding over **Operation Breadbasket, Jesse** became **Civil Rights' Blossoming Flower**
His tenacity and intellect made him the personification of **"Black Power".**
His friendship with **Floyd McKissick** and the honorable **Elijah Muhammed,** gave **Jesse** tremendous **insight**
For his later endeavors in the **"Human Rights"** fight.
His success in the movement caused friction and made **Jesse** to go his own **way**
So he started **Operation P.U.S.H.** in the **Civil Rights** hey **day.**
God was his guide in so many of his **fights**
So he saw it as his mission to lead **Black** people into the **light.**
In spite of so-called personal **faults, Jesse** would became the leader of all of the **oppressed**
He would even lend his hand to all protest candidates in election **contests.**
In the 80's Jesse reached out to **Minister Farrakhan** for help in getting the American pilot's **release**
This was a first step that eventually led to Lebanese **peace.**
This union of **Minister Farrakhan** and **Jesse** led to **Jesse's** presidential run of **1984**

Blacks would never be accused of being less intelligent any **more.**
The brilliance of **Jesse** and **Farrakhan** shook up the whole **nation**
The powers that be were collapsing on their own **foundation.**
The union of these two forces was something they didn't **envision**
So they set about to cause a Black **division.**
This union made **Minister Farrakhan** and **Jesse** the most
controversial men on **earth**
Their influences extended far beyond the country of their **birth.**
Jesse became in **American politics** a major **force**
He would in time become **America's** only logical **Presidential choice.**
Keep on Keeping on and your dream will come **true**
Because if you **"keep the faith, baby"** There is nothing **God** can't **do !**

Dedicated to the late Earlie Thorpe & the NCCU History Department.
Resident Aggie; Regina Miller of Newark, NJ

David Ruffin

David Ruffin introduced himself to the **world**
When he made magic with **Smokey's "My Girl"**
While **"My Girl"** was **flowing,**
He came back with **"It's Growing".**
The **Tempts** were still a **maybe**
When **David** told the world what had happened **"Since I Lost My Baby".**
During a brief **interlude,**
David took the **Tempts** to a **"Mellow Mood".**
When it looked like the **Tempts** would step down a **peg,**
David declared to the world **"I Ain't Too Proud To Beg".**
While **Smoky** was out **"Crusin",**
David told the world about **"Losin".**
When the weather got hot and bees started to **sting**
David told the world **"You're My Everything".**
David and the **Tempts** sent a message for all to **heed**
To let black people know that **"You're All I Need".**
David sung songs that were his for **keeps**
He let the world know that **"Beauty Was Only Skin Deep".**
Though **David** was plagued with many evil **ways,**
His consistency and persistency carried us to the next **phase.**
The road to stardom is rough no matter how meticulous you **are**
It take a lot of pain and suffering to become a **Superstar.**
David fell prey to a modern disease of the **mind**
He took that long and tortuous ride on top of **"Cloud Nine".**
Ruffin and the **Tempts** showed the world that Blacks were more than
just singers in a dance **hall**
But we were special people just like **Eddie, Otis, Melvin and Paul.**
At a time when all the artists were crossing over to the **other side**
The **Tempts** stayed in the pocket and instilled **Black Pride.**
Often times in this life things don't always happen as **intended**
You may face a lot of strife & that's how **David Ruffin's "Whole
World Ended"**
So **God Bless David Ruffin & The Temptations too,**
Because you showed us all it's not what you do, But **"The Way You Do
The Things You Do".**

Published in "The Final Call" 9/9/91 & 9/23/91
Co-Written by Bruce Bridges

To Michael From Dad

*Although the world now refers to me as being **late**,*
*I want to tell you that living my life with you was simply **great**.*
*You made my life as wholesome as could **be**,*
*You made me proud of being **me**.*
*Together we were a team hard to **beat**,*
*We did the impossible with the **three-peat**.*
*From the time you were born to the **NBA**,*
*You always did things your **way**.*
*All of my children were special to **me**,*
*But you showed me how special a father could **be**.*
*Now I'm in heaven riding with **God** on a **cloud**,*
*I want you to know that you made me so very **proud**.*

Dedicated to Michael Jordan and family

Tribute to a Fallen Warrior

Brother Malcolm X

Malcolm X, with the **Nation of Islam** as his **foundation**
Lifted his voice and shook up the **Black Nation.**
Malcolm X, using **Elijah Muhammed as his guide**
Exhorted pride in **Blackness worldwide.**
Malcolm's brothers and sisters knew that **Elijah Muhammed** was the righteous **one**
So they made it possible for him to meet his spiritual **son.**
So for some of you dumb brothers and sisters who don't have a **clue**
Elijah could say "I" in **Chicago & Malcolm** in New York would say "**Do**".
And since much of the speaking and actions did indeed come from his spiritual **son,**
All **Elijah** had to do was say the word and **Malcolm** would say "**thy will be done**".
As he moved from **Malcolm Little** through **Malcolm X** to **El Hajj Malik**
It was always an eye for an eye and never turn the other **cheek.**
Malcolm led with purpose and **direction**
He said we could never get our freedom participating in the white man's **election.**
Malcolm despised blacks who went around asking the white man for a helping **hand**
He said true freedom came from the acquisition of **land.**
Under Muhammed's guidance, **Malcolm built Mosques,** businesses and **acquired land**
He showed by example that this was the only way you could be seen as a true **man.**
Malcolm was a leader at the request and behest of the "**Messenger**"
On the ship that he was on, he was not the captain but the **passenger.**
Referring to Malcolm, writers have said "**you know the tree by the fruit it bears**"
We say "**You know a man by the love he shares**".
Malcolm grabbed brother **Louis Farrakhan** who had a desire to **sing**
And brought him into the **Nation** under **Allah's wing.**
With **Louis** at his side, **Malcolm** went to **Harvard** and embarrassed the best minds **America** could **produce.**

He showed them that the American Educational System was nothing but a big **ruse.**

Though **Malcolm** and the **Messenger** would eventually grow **apart,**
They would always remain together in each other's **heart.**
Malcolm could never forget that **Elijah** took him from the bottom of the **prison hole**
And lifted him on top of the **Black** leadership **totem pole.**
Muhammed came to **Malcolm** in his darkest **hour (prison)**
And plucked him up and made him his perfect **flower.**
He made **Malcolm** the example for all to **see**
Of what **Black** manhood is destined to **be.**
When you wanted information you didn't ask the man who went to **college,**
You sought **Malcolm** and the brothers because they had the **knowledge.**
Writer's from **Baldwin** to **Lincoln** fell under **Malcolm's spell,**
So he challenged them to accurately report on the conditions in the **Black man's hell.**
You came to **Malcolm** because you wanted to **know**
What was going down in the **Black ghetto.**

Farrakhan, Jackson and all the **Black leaders** of **today**
Were extremely influenced by what **Malcolm** had to **say.**
Malcolm raised conscious of all Americans both black and **white**
He showed, by example, that blacks are most precious in **God's sight**
While other blacks put white's out front while they stayed in **back**
Malcolm showed the world, "**The Essence of Being Black**".
Malcolm's writings woke-up writers of all **complexions**
They could now be independent and not wait for company **directions.**
You honor the **father (Elijah)** by honoring the **son (Malcolm)**
As **Jesus** said in the **Bible, "He and his Father are one".**
This tribute to **Malcolm** is a tribute of **love**
It is dedicated to all our **fallen warriors** in heaven **above.**

Co-written by Bruce Bridges

Janet
(Janet Jackson, Superstar)

Going to the top was the only way she could go,
As the youngest child of the dynamic Jackson Parents, Katherine & Joe.
As a child she showed she was the best,
When she stole the show portraying Mae West,
She continued to blow our minds,
When she had us all rocking to "Good Times".
With the unprecedented popularity of her brothers, Janet had always been
in the public eye,
Now through the tremendous impact of her music, we now know the reason
why.
During the famous Victory Tour, Janet decided she wanted to live large
So she eloped with one of the brothers Debarge.
In the brief marriage, Janet found it expensive to make his day,
So she eventually had to send him on his way.
Janet saw life was passing her by and she was getting old,
So with Jimmy Jam and Terry Lewis she reached for "Control".
She made all of us happy when we wanted to feel blue,
When she told us all how she felt "When I Think Of You".
At a time when we were searching for our proper stations,
She united us all with her second album "Rhythm Nation".
Life is full of highs and lows,
But Janet gave us perspective in "That's the Way Love Goes".
With the starring role in "Poetic Justice", Janet went over the top,
And showed that among today's stars,
She is "Cream of the Crop".

Berry Gordy
(Music Mongul)

Out of **Sandersonville, GA, Berry Gordy, Sr.** came
To **Detroit** in search of fortune and **fame.**
Berry, Jr. first tried out the boxing **ring**
But due to a string of misfortunes he realized this was not his **thing.**
Hooking up with **Jackie Wilson, Gordy's** song writing career went
straight to the **top**
With the release of several hit's including **"Lonely Teardrops".**
These hit songs made **Gordy** popular with the **honeys**
But it didn't result in him making big **money.**
Marv Johnson's "Come To Me" started **Gordy's move**
He would revolutionize the music world with his own special **groove.**
Along with **Raynoma** and finances from his family, **Gordy** started **Motown**
Because he was determined to show he was a man not the stereotype
black clown.
Using the teaching of his father's homeboy, the honorable **Elijah**
Muhammed, Gordy decided to do for **self**
He showed by example, how to put the so-called black ineptitude back
on the **shelf.**
"Money" was the first hit and showed that **Gordy** could get **down**
So he followed that up with Smokey's **"Shop Around".**
Under **Gordy's** tutelage, **Smokey, Holland-Dozier-Holland,** and all
other **Motown** writers would **thrive**
His company would bring young **Black America alive.**
Mary Wells, Diana Ross, The Temptations and the Four Tops were
part of the **Motown family too,**
Gordy Showed that with **God's** help, there's nothing you can't **do.**
After dominating the 60's, **Gordy** entered the 70's in **style,**
Introducing the world to the **Jackson 5** who featured a 9 year old **child**
(Michael Jackson).
Movies became the next challenge for **Gordy** to **use**
He would show the world his theatrical savvy in **"Lady Sings The Blues".**
Thanks **Mr. Gordy** for taking **Black America** on such a fabulous
musical **ride**
Because you more than any other person instilled **Black Pride.**

When I'm Old and Gray

When **I'm old and gray** don't caste me **aside**
Because by then heaven is only a short **ride.**
When **I'm old and feeble,** have mercy on **me**
Because **God** is bringing me closer to **thee.**
When the lights have dimmed and everything has gone **cold**
Don't push me aside because I've grown **old.**
Be my friend through thick and **thin**
Because I was there at the beginning and will be there to the **end.**
Help me **Father** to find my **way**
Because in your Kingdom is where I want to **stay.**
Give my children strength so that when life gets them **down**
They will know that through thick and thin, you will always be **around.**
May **God's** blessings be with us **always**
And help us make it through life's dark and turbulent **days.**

Inspiration: My friend Jackie

Published in "The Birmingham Times" 11-19-92

God Is A Friend

*When you are down and out with no place to **go***
*Never give up because your Lord is running the **show**.*
*When hope is dim and everything seems **lost***
*Never give up because **God** is the **boss**.*
*You're as good as anyone and better than **most***
*You are here as a tribute to your heavenly **host**.*
God** loves you all whether you are **black or white
*He only wants us to live our lives in his **light**.*
*He's there for us whether times are good or **bad***
*So try out goodness instead of being **so sad**.*
God** loves us all for who we **are
*Whether we are just a regular person or some shinning **star**.*
*Always remember that **God** is a friend you can always count **on***
*And as long as you live you are never **alone**.*

Inspiration: Louise Dixon, My Mother

Published in "The Birmingham Times" 3/4/93

Prince
(Singer, Creative Genius)

Though he seems private, he was **never alone**
He started his career with the dynamic **Andre Cymone.**
Family difficulties forced him out of his home at an early **age**
This would prove to be his foundation as he entered the world **stage.**
Andre's mother took him into her house and treated him as a **son**
The development of the musical **Prince** had just **begun.**
Mrs. Cymone had a heart that was blessed by **God above**
She gave a young **Prince** the most important thing in the world, **love.**
Prince along with **Andre** started the great **Minneapolis Music revolution**
With protégés like the **Revolution** and the **Tyme, Minneapolis** was
transformed into a musical **institution.**
Although for **Prince,** some of his personal life wasn't so **kind**
He exploded on the music scene telling us about **"1999".**
With numerous hits on his resume, **Prince** decided to go against the **grain**
And brought to the world **"Paisley Park"** and the hit **"Purple Rain".**
Prince was plagued by an intense desire for **perfection**
This led to his quick firings and numerous **defections.**
His music made love intimacies one of life's great **pleasures**
He showed his spirituality by resurrecting **Mavis Staples,** one of gospel
music's **treasures.**
Just when the **purple madness** had faded in this **land**
Prince scored again by doing the music for **Batman.**
With a new band, **Prince** again had that winning **gleam**
When he conquered us all with the number one (1) hit, **"Cream".**
In his new endeavors, may **God** always show him the **way**
Because when it comes to music he is here to **stay.**

Birmingham, 1963

Michael Jackson wants us to "remember the time"
But I choose to remember Birmingham!
*Black children being swept down the street by high powered **hoses**,*
*President Kennedy relaxing in a garden of **roses**.*
Birmingham!
*Martin Luther King languishing in the city **jail**,*
*The whole nation focused nightly on the black man's **hell**.*
Birmingham!
*The memory of the black children **screams***
*Martin Luther King could no longer speak of **dreams**.*
Birmingham!
*Malcolm X's unwise statements on the **Kennedy Assassination**,*
*Because his mind was clouded by events that shocked **the nation**.*
Birmingham!
A.G. Gaston, Martin Luther King, Abernathy, Malcolm X, Elijah
Muhammed** were the driving forces in this **town
Brutal treatment by the police forced blacks to go from passive resistance to
***really getting down**.*
Birmingham!
*Malcolm letting **Life Magazine** photograph the secret training of the **F.O.I**.*
*To let the world know we could get justice without waiting for "**the pie in***
***the sky**".*
Birmingham!
*The events in **Birmingham** gave fuel to the birth of New **Black Militant***
***organizations**,*
*The black man would never be the same in the world or **nation**.*
Birmingham!
*The sight of dogs biting black children's **fingers***
*The memory of the naked aggression still **lingers**.*
Birmingham!
*Martin Luther Kings' children safe in the comforts of **Alanta***
*King's encouraging 6 year old black children to carry the **Civil Rights***
***Banner**.*
Birmingham!
*Soweto, Sharpsville atrocities were bad as can **be***

*But the blueprint was made in the **Alabama city in 1963.***
Birmingham!
*Four Black Children killed in the bombing at **Sunday School***
*By white racist who defied all **rules.***
Birmingham!
Angela Davis,** as a young girl **understood
That we black people would be fools to sit down with white racists at the
*table of **Brotherhood.***
Thank you Birmingham

Published in "The Birmingham Times" 10/1/92

Joseph
(Joe Jackson)

Out of **Gary, Ind. Joe** came to make his **stand**
and produced the most talented family ever in this **land.**
Joe has always been potrayed as strict and **cruel**
But he knew what it took for the careers he **fueled.**
With the **Jackson Five, Joe** was the Father and the **brother**
Their focus on **Joe** made them love each **other.**
His business focus caused **Joe** to drive them so **hard,**
Because he wanted his family solid instead of being ripped **apart.**
In spite of his feelings toward **Joe, Michael** inherited his **drive,**
That's the main reason why his career continues to **strive.**
Michael and **Jermaine** were impressed with the **Berry Gordy** who
had been a millionare for **years,**
Not the broke **Berry Gordy** plagued with many **fears.**
Jehovah was **Joe's** guide in the lean **days**
Because **God** is around in so many **ways.**
Thank you **Joe** for helping your family avoid the **Rock and Roll sorrow**
Because in your innate vision you became **"the man who saw tomorrow."**

The Poetic Louis Farrakhan

When **Malcolm X** left the scene, the world asked **"who's next"?**
Little did they know that waiting in the wings was the dynamic **Louis X.**
Malcolm, for years, had groomed **Louis** to take his **place**
Because he knew that the fight for freedom was more than a one man
race.
As an entertainer **brother Louis** was second to **none**
Malcolm soon realized that this brother was the **chosen one.**
In music, he was one of a **kind**
So the **Messenger** gave him the music for the **mind.**
Farrakhan's radio broadcasts lit up the **air ways**
He gave direction and cut through the **maze.**
When the messenger departed, he was given the name **Hakim**
When you saw him in public, he lost that **gleam**
A very mean spirit entered into the **Nation**
Instead of talking about freedom, they started talking about
damnation.
The honorable Elijah Muhammed's name was dragged through the
mud
Denunciations by former followers came on like a **flood.**
Muhammad had warned that the Nation would soon **fall**
And darkness would engulf us all before we would again stand **tall.**
Allah entered the fray through **Brother Jabril**
He came with a message for a mind he had to **heal.**
The message raised up **Minister Farrakhan** and put him back on the
post
And he raised the conscious of **black people** from coast to **coast.**
With Allah's guidance, **Minister Farrakhan** brought the **Nation of
Islam back**
He brought out a new pride in the meaning of being **black**
The **Nation of Islam** provided the impetus for the resurgence of **black
thought**
It showed that we as **black people** had many battles that needed to be
fought.
Following the program of **the honorable Elijah Muhammed,**
Minister Farrakhan built a solid **organization**

So solid that he was soon to shake up the **Nation.**

Joining **Jesse Jackson, Farrakhan** entered the world arena by going to Syria to set the American pilot **free**

The world saw the image of what **Elijah Muhammed** wanted black leadership to **be.**

Jesse went to **Farrakhan** for aid in the **Presidential fight**

Together they rocked the **Nation** and were indeed **"Out of Sight".**

The **Nation** had never seen two diverse **black forces** together as **one**

We thought it would not happen until **"Gabriel"** blew his **horn.**

This **divine union** put **Minister Farrakhan** on the world **stage**

His eloquence and class embarrassed all the commentators that he **engaged.**

The more the press and government attacked him, the more popular he **got**

He showed the world that what **Elijah Muhammed** had taught him was indeed a **lot.**

Thanks to Allah for making this student of **Malcolm** and **the honorable Elijah Muhammed** the man he **is**

Because in his modest way, he has allayed all of our **fears.**

In Defense of the Messenger
(The Honorable Elijah Muhammed)

The honorable **Elijah Muhammed** was a great and consequential **man**
He dedicated his life to re-educating black people so they could make
their **stand.**
Muhammed, with **Allah** as his guide, was the moral force behind
Malcolm X and countless **others**
He showed us how to come together in unity & harmony as **brothers.**
When a man of **God** has relations with a woman, it's not for a cheap
thrill
It is for the divine fulfillment of **God's will.**
Children conceived by any means are never by **mistake**
It is because **God** knows the adult this union will **make.**
In the 70's the honorable **Elijah Muhammed** was honored by the
major cities throughout the **Nation**
This was a tribute to his moral **leadership & dedication.**
Most **Muslims** in **America** follow **Muhammed** either spiritually or
biologically
It was **Elijah** who made **Blacks** the example of **God's reality.**
Elijah took from the prisons some of **America's meanest**
And through his teachings made them **America's cleanest.**
He took hands that had once sold **dope**
and had them selling newspapers filled with **hope.**
He had former drug addicts engaged in international **trade**
Because the world realized that the men of the **Nation of Islam** had
made the **grade.**
He took old **Satan (Malcolm X)** out of the **Penitentiary**
And made him one of the pivotal figures of the **20th Century.**
Great writers like **C. Eric Lincoln, Alex Haley, James Baldwin &**
Louis Lomax fed off this **man**
They could be bold because of **Elijah Muhammed's stand.**
Established leaders like **Martin Luther King Jr., Roy Wilkins** & all
the others came to him for **advice**
He showed them how to stand up as men rather than be led like **mice.**
He took a flamboyant **Cassius Clay** & renamed him **Muhammed Ali**
Therefore, making him acceptable to all the **world's black family.**

The great modern **Arab** leaders **Nasser & Khadafy** looked to the messenger for **direction**
Because they realized through his teachings that he was **Allah's selection.**
As it is written, **God** will make the first from the **last**
So the messenger with his teachings & ministers like **Malcolm X &
Louis Farrakhan** showed the world **Islam's clean glass.**

Stevie Wonder

Stevie being blind, undoubtedly caused his mother a great **pain**
But what **God** took from his eyes, he gave to his **brain.**
His mother inspired him to be the best that he can **be**
In doing so he taught a lot sighted people how to **see.**
Stevie could never be considered as a **blind man**
Because he sees and hears if you really **understand.**
Being brought to **Motown** by **Ronnie White, Stevie** showed he could swivel his **hips.**
When he had the whole nation jumping with **"Finger Tips".**
His playing his **Harmonica** on the **Motown** bus caused many a sleepless **night**
He more than made up for it by coming back with **"Uptight".**
Numerous hits followed before **Stevie** decided to use his own **intuition**
So he revolutionized the music world with his monster hit **"Superstition".**
At a time when the world was dark with **strife**
Stevie brightened our day with **"You are the Sunshine of My Life."**
Despite all the adulation and fame his commercial success did **bring.**
Stevie took time off to rally for a holiday for **Martin Luther King.**
Stevie went against the grain while other stars ran for **cover**
He even had time to spare for his **"Part-time Lover".**
We now have a **King holiday** due to this man of **vision**
Stevie decided to stand up for a principle once he made his **decision.**
Thank you **Stevie** for being such a singer **extraordinaire**
Because in the entertainment and life you were always **there.**

Published in the Birmingham Times 6/3/93

36

B. B.
(*The Ballad of Bruce Bridges*)

Bruce put the seminar on the **air**
To let the world know that we were **there.**
Knowledge was the key that he had to **unlock**
He serves his community as a shepherd serves his **flock.**
He opened up ancient lands and history for all to **see**
From **Durham's Foxy** to **Raleigh's WLLE.**
He started at **NCCU's Student Union,** coming through the side **door**
And he culminated his efforts by broadcasting from his own **Know Book Store.**
From **Nathan Hare** to **Farrakhan** and all leaders in **between**
Bruce explained their positions and what they actually **mean.**
Bruce lectures all over the country and is always on the **go**
He even broabcasted from **Africa** on his **Cultural Awareness** radio **show.**
The purpose of this poem is not for **ego**
But to let the people know that as **Bruce** wrote at 13, "**Jim Crow has got to go**"
And we are not going to take **Crap No Mo.**
M.D. was in his teens and **Bruce** was 14 to be **exact**
But youth was no excuse for us not **act.**
Bruce worked tirelessly for **Black** people day after **day**
He didn't make excuses, he always made a **way.**
With guidance from the **Creator, Bruce** went out against all **odds**
He knew if he persisted his help would come from **God.**
We, of the **Black** community, are glad to have **Bruce** on our **side**
Because **Bruce** and **The Know Book Stores** of **Durham** and **Greensboro** represent **Black Pride.**

Burn Baby Burn
Jamil El Amin AKA (H. Rap Brown)

America applauded when **Stokely** left the scene after putting **Snick** (SNCC) on the **map**
But the smiles left their faces when the world encountered the dynamic "**Rap**".
Stokely Carmicheal had a high opinion of **Rap** and everyone wondered **why**
They found the answer when **Rap** expressed that "**violence is as American as apple pie.**"
Rap Brown, following the legacy of **Malcolm X** and **Louis X** (**Farrakhan**), stood up for truth and was persecuted for **it**
His book "**Die Nigger Die**" put him in line for an official government **hit.**
His becoming an officer in the **Black Panther Party** hastened the government **plot**
Because the government was determined to stop the "**Messiah**" coming from the **have not's.**
The government conspired to discredit **Rap** and put him in **jail**
Because he told the truth about a **Black Man's Hell.**
Rap was put in prison and the government thought this was the **end,** but **Allah** entered the picture and he emerged as **Jamil El Amin.**
With the blessings of **Allah** and the knowledge he has acquired, this is a powerful **combination**
This makes brother **Jamil** one of the most dynamic speakers in the **nation.**
May **God** bless you because you've given so **much**
to help all mankind to rid itself of racism and **such.**

Consultants: **Fahim Knight and Bruce Bridges**

"Clyde McPhatter"

Before **Motown** and **James Brown**, when music was placed on a **platter**
There was lighting up the airways, the **Bull City's** own **Clyde McPhatter**.
He hit the airways with a voice of pure **gold**
He was the founding father of a new music form that was later called **Soul**.
He got his first break with **Billy Ward** and the **Dominoes**
With **Jackie Wilson** as his **Understudy**, his smooth singing stepped on
many singer's **toes**.
His high voice laid ground work for future singers like **Smokey Robinson**
and the **Temptations**
His asking the proverbial **"Lover's Question"** became the anthem for lovers
throughout the **Nation**.
Atlantic Records, who would latter introduce **Aretha Franklin** to the
R&B World, was started for **Clyde**
At the foundation of **Black Music**, he was the most important **guide**.
Clyde's version of the **Bing Crosby** classic "**White Christmas**" established
the **mold**
For later **Black** entertainers to model after when they wanted to give a
song"**Soul**".
Clyde was born the son of a **preacher**
In Rock and Roll, he will always be remembered as the **Master Teacher**.

The Meaning of the "X"

The "X" was the honorable **Elijah Muhammed's** love offering to **Black people** wherever he found **them**
As for it honoring **Malcolm X**, it did not begin or end with **him.**
The "X" was given to show the commitment to the **nation**
It was the first thing that **Black people** had that was not from the **plantation.**
The "X" showed that you had decided to stand up and be a **man**
And decided to do for self and quit begging the **White man** for a helping **hand.**
The "X" provided a new start for our life to **begin**
So we could purge ourselves of strife and **sin.**
The "X" provided **Blacks** with a tremendous sense of **hope**
It caste away all fear of the **white man's rope.**
The "X" declared to the world that your eyes had opened and you had been **re-educated**
It provided the degree of commitment to the upliftment of the **black nation** that your life was now **dedicated.**
Malcolm Little lived a life of crime and was locked up in **jail**
But he emerged as **Malcolm X** and cleared up conceptions about heaven and **hell.**
Malcolm Little was sent to prison and left for **dead**
But the honorable **Elijah Muhammed** raised him up as the revolutionary **Malcolm X instead.**
The "X" will always be considered as the most important **key**
To unlock the door to freedom and knowledge for you and **me.**

MLK

Coming out of **Atlanta, Martin** was born to be **great**
He made his life's work a commitment to ending **America's** appetite
for **hate.**
God was his leader, even when he was a **child**
Because he was geared toward leadership while other kids ran **wild.**
His father's strength in the face of adversity, had a powerful effect on
King
He would use this strength in his efforts to let freedom **ring.**
After a brilliant education and a blissful marriage to **Coretta Scott**
King went to **Montgomery** to fulfill his mission to help the **have-nots.**
The murder of **Emmitt Till** lit a spark in **Blacks** throughout the
nation
Therefore **Rosa Parks** was inspired to react to bus **discrimination.**
King, with the **Montgomery Cadre,** led the great **Bus Boycott**
Their efforts on behalf of equality came at a time when they really
meant a **lot.**
The efforts in **Montgomery** made **King** famous and also a marked **man**
He became an object of official scrutiny wherever he traveled in this **land.**
King and his best friend, **Abernathy,** continued to fight against
discrimination
But the spectre of their greatest struggle loomed in his immediate
destination.
Brimingham, Alabama would be the ultimate **goal**
It would expose the world to **America's** racist **soul.**
The speech at the "**March on Washington**" would highlight **King's**
oratorical **career**
But the climax of the **Non-Violent Movement** was so very **near.**
The violence in **Birmingham** left **America's Blacks** with a bitter **taste**
The people realized that a life is too precious to **waste.**
After **Birmingham, Martin** focused more on economic
discrimination
He found out that race was the basis for **Black** poverty and
degradation.
J. Edgar Hoover accused **King** of being a man of **lies**

But the world honored him and refuted **Hoover** by awarding him the **Nobel Peace Prize.**

King's faith in **God** let him know that his days were **numbered**
So he concentrated more on how he wanted to be **remembered.**

His book, **"The Trumpet of Conscience",** showed a more focused **King**
He realized, like his mentor, **Dr. Benjamin Mays,** the responsibilities that true freedom would **bring.**

King's opposition to the **Vietnam War** ended his role as a so-called **White Man's Tool**
He stood up for principle to show that he was **God's** man and not anyone's **fool.**

Official involvement in his assassination in **Memphis** was without any **doubt**
The people who count, simply wanted **King out.**

King, along with **Abernathy,** inspired us all with their strength in the face of **adversity**
They showed us that with **God's** help, there's no limit on solving racial **diversity.**

Black Is Best

I always have looked at myself as being proud of being **Black**
Now with the **Afro-American** craze, the name itself is under **attack.**
My ancestors were **Black** if you can **understand**
When **Amerigo Vespucci** first staked his claim in this **land.**
Before **Leo Africanus** ever made his **claim**
We had the word **Black** in our **name.**
These two **Europeans** were great map **makers**
They are not worthy of us honoring them by becoming name **takers.**
Slavery supposedly ended in **1865**
Let's stop all this foolish **African-American Jive.**
Elijah Muhammed said that we were proprietors of all the earth's **land**
So you see this makes us more than just an **Afro American man.**
God made us in the image of **himself**
So let's put this foolish nonsense back on the **shelf.**

Dedicated to My Son, Michael Malik

Published in "The Birmingham Times" 7/1/93

Reparations 1993

Are we Blacks due payment for services **rendered?**
Or should we forget about it and go forth **unhindered?**
Did our 400 years of bondage carry a **price tag?**
Or should we praise **Abe Lincoln** and salute the **American Flag?**
We see **African** and **Arab** leaders living high on the **hog**
With riches that were stolen from our ancestors when their ancestors
sold us like **dogs.**
Blacks were sold into bondage due to human **greed**
They came to the Americas and fulfilled a very pressing **need.**
Blacks cut through the wilderness and made **America** nice and **neat**
The slave trade provided the foundation for the financial capital of the
world, **Wall Street**
The same politicians who support sanctions on **Iraq** for it's attack on
Kuwait
Accuse Blacks who want reparations of teaching **hate.**
The whole world owes reparations to the **Black man**
In addition to monetary we need our own **land.**
A worldwide conspiracy brought the Black into **bondage**
So it's time for the world to pay for the **Black carnage.**

C. Eric Lincoln, Scholar

Being a distinguished scholar is something that **C. Eric** has continually **strived**
Because he knew that once **Black** people advanced from **Black is Beautiful**
to **Black is Powerful** they would have **arrived.**
His career started by brightening up baseball's dog days of **May**
When he signed up the greatest baseball player ever **"Say Hey" (Willie Mays).**
Teaching at Clark University proved to be a pivotal move in **Black History**
Because he opened the door to a religion shrouded in **mystery.**
A student's essay gave **C. Eric** the **clue**
To what God's intent was for him **to do.**
He took an unknown movement off of the back **page**
And through eloquence and penmanship put it on the world **stage.**
The honorable **Elijah Muhammed** gave **C. Eric** the green **light**
To use his pen to further the black liberation **fight.**
Dr. Lincoln introduced **Malcolm X** and **Louis Farrakhan** to the world
through his **book**
The Title also provided the name for the members that the press **took.**
"The Black Muslims in America" proved to be the work that all later
books used for **reference**
Its style and intellect attest to **C. Eric's excellence.**
The honorable **Elijah Muhammed** knew that **Dr. Lincoln** was the **best**
When he chose to take **Dr. Lincoln** to the airport in the **Lincoln** instead of
the **Cadillac** in honor of his **guest.**
C. Eric and **Malcolm X** became as close as **brothers**
Despite their sometime intellectual sparring they always looked out for each
other.
Alex Haley is one of his best friends and came to him for **advice**
When he wanted to do the book on **Malcolm X's life.**
Despite his international fame, **C. Eric** is a modest **man**
He saw a just and righteous cause so he made his **stand.**
"The Black Muslims in America" and other books were detours for the
original book that he wanted to do, **"The Avenue, Clayton City"**
Because he felt there were important people from his hometown that the
world need not **pity.**
At Duke University, **Dr. Lincoln** is a role model for all people that he talks **to**
He shows, by example, how to handle eloquence and fame, and just be **you.**

*Thank you **Dr. Lincoln** for carrying black history this **far***
*Because **God** has made you black liberation's shining **star**.*

Miss Ross, The Boss

The Supremes *would be the vehicle for* **Diane,** **Mary** *and* **Flo**
To come to the world's attention by asking **"Where Did Our Love Go?"**
Their presence produced **Black Pride** *for all the world to see*
When they told their lover to **"Come See About Me".**
The Supremes *phenomenal success put them under the* **gun**
So they let us know they had **"Nowhere to Run".**
Diane *was the star with a voice from* **above**
When she let the world know about her **"Baby Love".**
With **Holland-Dozier-Holland's** *Music fueling their* *flurry*
The Supremes *told us all that with love* **"You Can't Hurry".**
Though the **Supremes** *were on top and birds of the same* *feather*
Diane *said good-bye with* **"Someday we'll be together".**
Miss Ross *decided that she wouldn't be* **Second Banana**
So she insisted to the world that they call her **"Lady Diana",**
She debuted at Number 1 with **"Ain't No Mountain High"** *as a* **Solo**
She let us all know that there was noplace she couldn't **go.**
Although it was **Gladys Knight** *who discovered the* **Jackson 5,** **Diana**
took a special interest in their **career**
This is the main reason she holds the tremendous success of **Michael**
Jackson *so* **dear.**
Diana *gave an* **Academy Award** *winning performance in* **"Lady Sings the**
Blues"
But envy and racism in the **Academy** *caused her to* **lose.**
Diana *has been a role model for blacks in spite of* **herself**
She gave all she had to give and left nothing on the **shelf.**

M. J.
(Michael Jackson)

Michael burst on the scene with an act that was no jive
As the dynamic lead singer for the Jackson Five.
Motown was waning and they took up the slack
With the number one hit single, "I want you back."
Michael and the Jacksons had captivated the world
And it was fitting they would have a hit called "Mama's Pearl".
Although Michael and the Jacksons were number one, he had a bigger fish to fry
So it's ironic that one of the last Jackson Five hits was "Never Can Say Goodbye".
After leaving Motown, M. J. starred with his old friend Diana in the "Wiz"
There he made connections with Quincy Jones and they would revolutionize the Music Biz.
Their first collaboration, "Off The Wall," proved to be a killer
But looming in the horizon was the greatest selling album in history, "Thriller".
Although "Billie Jean" didn't actually introduce Michael to the world stage
It signaled the advent of the video age.
The controversial Thriller Video showed the highly creative M. J.
But the spiritual Michael pulled it when unenlightened pundits said it led to moral decay.
Just when everyone had concluded that M.J.'s life was so sad
Mike announced to the world that he was "Bad".
Michael took a look at the "Man in the Mirror" to find his way
So he, along with Lionel Richie, composed "We Are the World" to bring to starving people a new and brighter day.
"Black or White" showed Michael's love of all Mankind
But he showed his Black pride in "Remember the Time".
Thank you Mike for being like your childhood idol, James Brown always there for us
And saying in your music, it is in God in whom we should put our trust.

Published in "The Birmingham Times" 8/26/93

Aretha

As the **Rev. C. L. Franklin's** daughter, **Aretha** learned at an early **age**
That in life or show business the world is a **stage.**
A young **Smokey Robinson,** her brother's best friend, fell in love with
Aretha before he ever met his **wife**
She would in a special way remain the big love of his **life.**
Gospel was her first love in music and would remain a constant **force**
She even took it with her later when she made her musical **choice.**
First as a blues singer she realized she was missing her **call**
Because her music was not satisfying her at **all.**
She confided to close friends that she was being held **down**
She decided to stand up and be counted and not be anyone's **clown.**
Under guidance of **Jerry Wexler,** few knew what to **expect**
When she would revolutionize the music world by demanding **"Respect".**
She made the other singers look like they weren't singing at **all**
When she expressed herself responding to the **Lord's call.**
God was her guide even when her husband tried to cloud up her **day**
She told him and the rest of the world **"It Ain't No Way".**
When **Angela Davis** was in trouble, by offering to put up bail money, she
showed a heart of pure **gold**
She gave honor and commitment to the title she was given **"Queen Of Soul".**
Aretha, we are honored to have you as our **Queen**
You have proved yourself to be the greatest **soul singer** the world has ever **seen.**

Black Justice U.S.A.
(Rodney King and Others)

Rodney King's beating forced a lot of blacks to face the **reality**
Of *Elijah Muhammed's* statement that the only thing you could expect
form the white authorities was **brutality.**
The not guilty verdict by a **predominantly white jury**
Drove millions of blacks into a frenzied state of **fury.**
Did you brothers and sisters really think that a white jury would take a
stand
For one of the brothers who was formerly considered **3/5's of a man.**
Mike Tyson was convicted because he was **black**
The white officers were acquitted even though the **world witnessed** their
vicious **attack.**
Martin Luther King's main thrust was not **prejudice**
But **America's** systematic program of **Black injustice.**
If we study the **Dred Scott Decision,** we would know what to **expect**
When the court said that blacks had no rights that whites were bound to
respect.
Blacks shot numerous times by police have been charged with **assault**
By a system that criticizes all others but is blind to its own **faults.**
The answer for blacks is black autonomy and **self-rule**
It is time for us to stop being the **white man's fool.**
God is the answer and not the **President**
So we must choose not of the world but a leader who is **heaven-sent.**

Historical consultant Bruce Bridges, owner of The Know Book Store

Marvin Gaye

Marvin came to Motown with a desire to play Jazz and be mellow
But he came to our attention as a "Stubborn Kind of Fellow."
Rock and Roll was something that he didn't particularly like
Until he showed us all how to "Hitch Hike"
He gave young people a new place to meet
When he collaborated on Martha and the Vandellas' "Dancing in
The Street."
"Ain't that peculiar" was used to set a particular tone
He followed that up with "I'll Be Doggone."
Marvin was also plagued with a confused mind
But he stunned the world with "What He Heard Through the
Grapevine."
With Tammi Terrell, he knew he had the right stuff
So he told us all "Ain't No Mountain High Enough."
When Tammi died Marvin wanted to be left alone
When he emerged from his hiatus, he asked "What's Going on."
His concern for the environment was plain to see
He gave the world the Ecology anthem "Mercy Mercy Me"
When it looked like He was long gone
He shocked us all with "Let's Get It On."
Despite his success Marvin could not find peace in his life
Not with a bevy of girlfriends nor a long suffering wife.
Coke became his remedy for pain
But he found like all of us it was all in vain.
Find God and you will find peace
In this life he will give you a new lease.
We all loved Marvin and his music gave us great joy
Because it was from the heart and not just a ploy.
We all reacted in horror
When Marvin's life ended in such sorrow.
We were blessed to have Marvin for the time he was with us
Because he told us in music, it was only God we can trust.

Eddie
(Eddie Kendricks)

Oh Eddie, thank you for brightening up our **day**
Because you gave us years of love before you just **"faded away"**.
Coming out of **Birmingham** with your childhood friend **Paul Williams**, you would become a **Prime**
But the dreams of youth were ahead of their **time**.
It was you who went to the **Mother of Diana Ross**,
To get her to join your sister group **The Primettes**, years before she became a **Supreme** or the **Boss**.
With demise of the **Primes, Eddie** decided to take it on the **Lamb**
So he went back home to **Birmingham**.
On a visit to fellow **Prime, Paul Williams in Detroit, Eddie** gave **Otis Williams** a **call**
Otis asked **Eddie** to join him in a new group that, at Eddies insistence, would also include **Paul**.
Signing with **Motown** and becoming **The Temptations**, many considered them a **flop**
But as in coffee the **cream always rises to the top.**
Eddie did the demos for future **Motown hits**
It was **Eddie** who was responsible for the **Tempts** revolutionary stage **outfits.**
Although, **Clyde McPhatter** first brought the high voice to a rock and roll **group**
It was **Eddie** who made it an integral part of the vocal **loop.**
The **Temptations** first hit **"The Way you Do The Things You Do"** was done with **Eddie on lead**
He and the **Tempts** provided the voices for all young people to **heed.**
Eddie was everyone's favorite **Tempt** and told us what to **do**
When your baby was giving you trouble, to ask her, **"Girl Why You Want To Make Me Blue".**
You told us what to tell our **steady,**
I'm on my way so baby **"Get Ready".**
With **Diana Ross**, you showed us how smooth love could **be**
When you had the whole world singing, **"I'm Gonna Make You Love Me".**
Though the **Tempts** were on Top in the World and **Nation**
You said farewell with **"Just My Imagination".**

*You left the **Tempts** to go your own **way**.*
*Instead of flopping you produced number one hits, **"Boogie Down"** and*
***"Keep On Trucking"** in your hey **day**.*
*Thank you **Eddie** for giving us so much **pride.***
*Because as you said that with love, it always has **"Two Sides".***

Dedicated to Linda Jo

Smokey Robinson

*You meant a lot to us when we had processes in our **hair***
*Because you took us on a trip **"Way Over There".***
*When all the sisters wanted to be serious and get **down***
*You gave all the brothers the warning that we better **"Shop Around".***
*Along with **Gordy,** you were there at the founding of **Motown***
*Your music fathered and nutured a generation of **black children** in all of*
Americas towns.
*You meant more than you'll ever **know***
*To a lot of black youths who lived in the **ghetto.***
*Whenever we felt **blue***
*You told us to always **"Try Something New".***
*You sent **Mary Wells'** career to the **sky***
*When you gave her the lyrics to the song **"My Guy".***
*You showed us all that you could get **Funky***
*When you had us all doing **"Mickey's Monkey".***
*We found out you were for **real***
*When the **Marvelettes** told the world **"Don't Mess With Bill".***
*You enamored yourself to all the women of the **world***
*When you gave the **Temptations** the classic **"My Girl".***
*When you sung **"Oh Baby Baby",** your voice came from **above***
*You warned the women if you left they'd **"Lose A Precious Love".***
*Later in a departure from the **norm***
*You revolutionized music with your epic **"Quiet Storm".***
*When it looked like your career was just a **blur***
*You surprised us all with **"Just To See Her".***
*Always remember, that **God** put you in a very special **mode***
*Thanks for staying the course and not succumbing to the **"Fork In The Road".***

Power Poems II

The Lyon Family

Leonard Lyon was a great man even though he never owned a car
Because he made life for himself and others "Fine and Dandy so far".
He married Mabel Dunston in about 1917
She would remain in life and death his one and only Queen.
God was the driving force in my Grandparents's life
That's why they could be optimistic despite all the pain and strife.
My Grandparents made their house a happy place for their kids and all
the kids of the neighborhood
Because life and its meaning was something they well understood.
Of their union was born seven girls and a boy
Each one, in their special way, would be their own bundle of joy.
Leonard Jr. was the first and Barbara would be the last
Each child would exhibit their own special class.
God was the inspiration and gave my Grandparents strength
He gave them the fortitude to live their lives to its length.
Thank you Grandmother for being the special lady that you are
Because God has made you his own shining star.

Dedicated to: Leonard, Jr., Christine, My mother, Louise, Helen, Mabel, Ernestine, Juanetta, and
Barbara (the Lyon Children).

Special dedication to my sister Claudia and my uncle Johnny.

A Short Prayer

Thank You Lord for being so kind.
Thank You for taking control of my mind.
I'll always be Your servant in every way.
So help me to make it day by day.
I'm honored that I am putting your message across.
Without You all of humanity would be lost.
Give us blessings on this beautiful day.
Give us the light so we can find our way.

God Is Love

Help me Lord to overcome all problems in my **way**
Give me peace of mind day after **day.**
Show me God the true heaven on **earth**
Give me strength to face the obstacles in the land of my **birth.**
Give me power in the face of **adversity**
Give me the strength to face life's **diversity.**
Bless me **Lord** as you show me the **way**
Guide my life, come what **may.**
Bless my children as they go into adult **life**
May you always guide them through suffering and **strife.**
Help my brothers and sisters realize that you are the **King**
And they have nothing to fear regardless what the "**powers that be**"
bring.
Thank you **God** for guidance from **above**
Because you are indeed the **God of love.**

City of Angels
(Los Angeles)

*Beware you hustlers out in **L.A.** on the **make***
*Because **God** is in the picture so today he makes you **shake.***
*The city was given the name for a very special **reason***
*So you wicked better abandon it because evil is not in **season.***
*The **Brotherhood Crusade** and **Churches** have tried to teach you the **way***
*But since you would not listen, now **God** is having his **say.***
*The great people of **Los Angeles** are sick of the violent **gangs***
*But the **Almighty** is sick of all the crime, so he gives you the **big bang.***
*Forget wickedness and live your life in the **light***
*Then your **heavenly Father** will make things **alright.***
God** used **L.A.** as an example for the rest of us to **see
*That if we don't straighten up, the same catastrophe will be visited on you and **me.***
God Bless The City of Angels

Religion and the Slave Mentality

*So many **black churches** regardless of **denomination***
*Are honored to have **white people** in their **congregation.***
*A lot of our **brothers** think that the **Nation of Islam** is **wrong***
*Because they themselves, want **fellowship** with **other** than self and a **return***
*to the **plantation** where they think they **belong.***
 *To pray with an Arab, is **heaven** for some of the **Orthodox** brothers,*
*because they are close to **white***
*So through their **slave mentality**, the **Nation** is **wrong** and they are **right.***
Malcolm X** is portrayed, after taking the **Hajj**, by some of these **brothers
*as an **intergrationist figure***
*But **Malcolm**, being **grounded** in the **teachings** of the **honorable Elijah***
Muhammed**, said **himself** that in **America**, he was just another **"Nigger".
Malcolm** purposely kept his **Muslim Mosque, Inc. all-blacks
*Because he knew that we could only be **lifted** up by our own **backs.***
Love** of self and **kind** is not racist but **heaven sent
*Because **God** wants our **mental emancipation** from the **plantation** where*
*for 400 years, we have **spent.***
Us** coming together in **unity** will have a definite effect on **others
*We can then make the **righteous** people of the world our **brothers.***
Biblically speaking**, you should love your **neighbor** as you love **yourself
*So Minister **Farrakhan**, through his **teachings** is putting **racist attacks***
*back on the **shelf.***

*Consultant: **Fahim Knight and Bruce Bridges***

What Is A Mother

A mother is one who endures the pain of death to give you **life**
Even though her life might be full of turbulence and **strife.**
What is a mother?
A mother is one who sacrifices her all to give you the **best**
who through her concern for you never has time to **rest**
What is a mother?
A mother is a person who upon hearing that her child is **dead**
ask **God** *sincerely why he didn't take her* **instead.**
What is a mother?
A mother is one who seeing her child happy gives her great **joy**
even though her man deserted her or is just being **coy.**
What is a mother?
A mother is one who puts everyone else ahead of **herself**
By putting selfishness and ego on the **shelf.**
What is a mother?
A mother is a person who by nature is herself set **apart**
Because she above all creation is the vehicle of **God.**

God bless all the mothers of the world

Reflections on the Million Man March

*The **Million Man March** was indeed out of **sight***
*Never in history have so many **black men** got together without a single **fight**.*
*Under the leadership of **Minister Farrakhan and Reverend Ben Chavis**,*
*the **Black man** declared our rights as a **man***
*Because we could never be respected as leaders unless we made our **stand**.*
*The **March** was also a declaration of independence on our **part***
*Because the quest for **freedom and justice** starts first with the **heart**.*
*Our struggle has been going against the grain no matter what we **strived***
*But with this **March**, we learned that as **Caulbert Jones** used to say,*
*"**When you get to black is powerful, you will have arrived**."*
*When **Dr. Lyons of The National Baptists** refused to endorse **the March**,*
*it was like divine **intervention***
*Because **Martin Luther King's** number one opponent was **Dr. Jackson**,*
*also the head of this same **National Baptist Convention**.*
*Conservative pundits, **who** predicted a flop, were embarrassed to no **end***
*Especially since **Minister Farrakharts** speech was the highest rated live*
*speech in the history of **CNN**.*
*Congratulations to **National Co-ordinator, Ben Chavis** and the men of*
*the **F.O.I**.*
They showed us that all things are possible as long as you keep your head to
*the **sky**.*
*Many thanks to **Minister Farrakhan** for letting **Allah** show him the **way***
*To make **The Million Man March**, the dream of the **Honorable Elijah**
***Muhammad and Malcolm X**, a **Black Liberation Day**.*

Trial of the Century

At long last the **Juice** is finally **free**
By example showing what we as a people want to **be**.
The **California Justice System**, the vicious killers of **Brother George
Jackson** and countless **others**
Think that we are fools when they want us to believe them when they come
after our **brother**.
The charge against **O.J.** was a set up from the beginning to **end**
By the new **Klansmen** in police uniforms pretending to be our **friends**.
Prominent **Black** men like **O.J.** and **Michael Jackson** are being charged
with some kind of **abuse**
By a system determined to corral **Black** manhood into a racist **noose**.
Feminist organizations can't see the light even though it's in their **face**
The purpose of these allegations is not for justice but to keep the Black man
in his **place**.
The **Dream Team**, led by **Johnny Cochran**, did a marvelous **job**
Against a system that promotes **Black** men as people who only kill and **rob**.
O.J. was charged with murder because he was **Black**
White America wanted him crucified and dead flat on his **back**.
Johnny Cochran, Geronimo Pratt's lawyer, defended **O.J.** to the **hilt**
He showed that with education and **Black** consciousness, a solid foundation
can be **built**.
May **God** bless **O.J.** as he enters his new **life**
And hopefully regains his consciousness and makes a sister his **wife**.

God Is The Way

When darkness is across every spectrum of your **life**
 and you can't see light through all the suffering and **strife.**
God is the way
When it looks like the hand of the devil is in everything you **do**
Just hold on to the faith of **God** will pull you **through.**
God is the way
When you feel as though everything is wrong and you don't have a **friend**
hold on to the **Lord** and he will be there to the **end.**
God is the way
When the doctors tell you there is no **hope**
and you feel like your at the end of your **rope.**
God is the way
So my friends don't let the problems of life rip you **apart**
because **God is the way** if you keep him in your **heart.**

Whitney Houston

*Coming out of **Newark, New Jersey, Whitney** had a voice from **above***
*As she had us all titillating with "**You Give Good Love**".*
*Being the sister of **Marquette's** legendary "**Music Man**" (**Gary Garland**),*
Whitney** was destined to be **great
*Having a mother like **Cissey** and a cousin, **Dionne Warwicke** further*
*sealed her **fate**.*
*When we were running out of chances and didn't know what to **do***
Whitney** made us all feel good when she told us all she was "**Saving All
***My Love For You**". With great promotion from **Clive Davis** and the*
*production skills of **Kashif and Narada Michael Walden, Whitney** went*
*over the **top***
*She showed that among today's singers she was the best of the **crop**.*
*With number one hits like "**How Will I Know**" and the "**The Greatest***
Love Of All**", **Whitney** showed us that love was **alright
*And with **Baby Face** and **LA.**, she further punctuated her soulfulness with*
*"**I'm Your Baby Tonight**".*
*Being successful and **Black** caused **Whitney** to become the subject of*
*scrutiny of tabloids in the world **around***
*She secured her personal life when she became the bride of "**Mr. My***
***Prerogative**", **Bobby Brown**.*
*With **Kevin Costner, Whitney** made her cinematic debut in the movies,*
*"**Body Guard**"*
The tremendous success of the movie and subsequent sound track are the
*things that set **Whitney apart**.*
*"**I Will Always Love You**" proved to be the greatest hit ever in the **world***
*But **Whitney's** greatest production came when **God** gave her and **Bobby** a*
***baby girl**.*
*May **God** continue to bless **Whitney** because she has always given her **best***
*To show That if you are in the faith, **God** will give you the **rest**.*

The Soul of Aretha

Aretha entered our lives the daughter of Reverend C. L. Franklin, one of gospel musics who's who
Then she told the world, "I Have Never Loved A Man The Way I Love You".
Aretha made "Respect" her national anthem and told us things are not as they seem
By telling her lover "Don't Let Me Lose This Dream".
Arethas's singing put all of her competitors on the shelf
Because the Queen of Soul was in a class by herself.
Aretha's only down side was a string of possessive men
With the appointment of her brother as her manager, this too came to an end.
Aretha's singing reached black people's souls
In her hey day, she was really something to behold.
After years of dominating the music world as our Queen, her biggest challenge was ahead
After her father was shot by burglars and left for dead.
Aretha stopped her career to care for her comatose dad
But this tragic situation for her fans was doubly sad.
Aretha was married to Glyn Thurman for several years but it didn't last
Because Aretha's catering to the whims of men had long since passed.
In recent years, the deaths of her father, her brother and her sister, Carolyn caused Aretha to slow
But the legacy of being the Queen and a mom keeps her on the go.
May God continue to bless you because you are indeed on your own
Because with him as your guide, as I wrote in "God Is A Friend", you are never alone.

Dedicated to my daughter, Tamera

Black Panther Party

*Although for the **Black Panther Party**, history has not been **kind***
*The **Movement** itself woke up a dormant **Black mind.***
*Founders, **Huey Newton** and **Bobby Seale**, were influenced by **Sixties***
Leaders, Malcolm X** and **Martin Luther King
*They decided to carry the **Movement** to the next level rather than just let it*
*be a **fling.***
Being highly educated, these brothers challenged the government with its
*own **laws***
*They embarrassed the **Eagle** by robbing it of it's **claws.***
*Going to the **California State House** with rifles was done to show the*
*inadequacy of gun **control***
*But the **"Powers That Be"** used this to show that the **Movement** was*
*violent and that it must **fold.***
*Members were taught government regulations and given law **books***
Black** people, protected by the **Panthers**, could no longer be labeled as **crooks.
*Dynamic leaders, **Elridge Cleaver, H. Rap Brown** and **George Jackson**,*
*lit a fire in **Blacks** throughout the **nation***
Despite the fiery rhetoric, through government infiltration and alliances, the
Movement** itself was on a shaky **foundation.
*Government agencies conspired and killed leaders of the **Movement***
Other leaders were forced to flee the country under relentless pursuit by the
US Government.
Brother Huey** became a frequent resident in state **jails
*Because he refused to compromise on the **Black Man's hell.***
*other leaders had their claws **defanged.***
*By government leaders determined to end the **"Big Bang".***
Brother Huey** is dead but his vision lives **on
*Because **"Power To The People"** will live long after all of us are **gone.***

Black History

Historically speaking **Black** *history has been shrouded in* **mystery**
Because in reality, it means being **Blacked** *out of world* **history.**
Great Black warriors *of the ancient past, like* **Imhotep,** *have been pushed aside*
In favor of meek leaders that the establishment brings forward to give us **pride.**
The history of the **Black Man** *is known to all of the world's* **nations**
As **Napoleon's** *scientists pointed out that although* **Egypt** *of the 1800's was racially mixed, the* **Black** *slaves are the foundation of* **Western Civilization.**
Black *libraries were plundered and burned and records were* **altered**
To make sure that **Blacks** *trying to build on the past dreams would* **falter.**
Africa *was depicted as the land that contributed nothing to world* **civilization**
This was part of a world wide conspiracy to foster in white **domination.**
Africa, *the home of civilization, became a land of tribes and savages,* **too**
Blacks *were portrayed as a brainless people waiting for* **Tarzan** *or some other white man to tell them what to* **do.**
The **"White Man's Burden"** *was used as justification for the slave* **trade**
The home of the world's religions **(Africa)** *also became the land where new converts were* **made.**
Blacks *became pawns in the world's power* **games**
Europeans *destroyed our history and gave us their* **names.**
Despite the **Europeans** *best efforts to destroy* **Black** *history, history always leaves* **footprints**
Because **God** *was in the picture and* **He** *revealed historically what the Black man had* **lent.**
Black *history will put an end to the world's* **miseducation**
Because the world will find that **Reading, Math, Science, Culture, and Medicine** *started in* **Africa,** *the home of the first man and world* **civilization.**

Medgar Evers

*Medgar Ever knew that **God** had made him a **man***
*So it's fitting that he chose his home **Mississippi** to make his **final stand***
*After a stint in the **Military**, **Medgar** became the field rep for **NAACP***
*He was determined to make conditions for the blacks the best that they could **be**.*
*Medgar always considered **Civil Rights** a job for **men***
*So he was, at first, reluctant when students offered a hand to **lend**.*
*The **Mississippi** demonstrations became a model for the **nation**.*
*Under **Medgar's** leadership, they set the mode for **strength and determination**.*
*Although **Malcolm X**, when it came to intergration, was on the other **side***
*He always looked at **Medgar Evers** with a great sense of **pride**.*
*Medgar became the greatest field secretary for the **NAACP***
*His effectiveness and leadership didn't rest well with **the powers that be**.*
*Although the world has chosen to **Martin Luther King***
*It was the efforts of **Medgar Evers** in **Mississippi** that really made **freedom ring**.*
*Conspiracies in the highest levels of government caused **Medgar** his **life***
*Because the deaths of so called **"Black Messiahs"** was the official way of solving **racial strife**.*
*Thank you **Medgar** for giving your life for **us***
*Because you and your followers efforts broughts us to the front of the **Freedom's bus**.*

Dedicated to Dr. C. Eric Lincoln

To Bill Clinton
From M.D. II

Mr. Clinton all of America wanted to give you the benefit of the doubt
But with your Pearl Harbor attack on Iraq you let it all hang out.
This attack on Abraham's home is an attack on God
So it wouldn't surprise me if He sent another Hurricane Andrew to rip
this country apart.
You told the world that support of the principles of M.L King was strong
But your actions show the King you support last name is Kong.
Mr. Clinton your action came through very loud
And gave a great signal for the despicable drug crowd
Why are you so concerned over the so-called Iraqi plotted Bush
assassination
When you and your advisors killed him politically in this nation.
We elected you on hopes of the peace we thought you could bring
Your action show that all you have to offer is the same old thing.
You trusted the F.B.I & C.I.A & their so-called reliable information
Have you forgotten that they have never cleared up the King and Kennedy
assassinations.
War is not the way to bring peace on Earth
It is up to us to whether we have continued chaos or spiritual rebirth.
We all hope you forsake your Hitler obsession & bring God into your life
And He will rid your mind of all this hatred and strife.

The World In Black

Randall Robinson's defense of U.N. policy in Somalia set off bells of alarm
The world's foremost African spokesman has become a notorious Uncle Tom.
How does Randall have the audacity to defend such a man
Who has plundered and killed black people on all of the earth's land.
The disposal of James Jordan's body shows that we have a lot to learn
That when you are black in America, you will eventually burn.
Michael Jackson is standing accused of child abuse
By gold diggers who want to take advantage of this golden goose.
The attack on the black man is coming from within and without
It probably won't cease until God uses His clout.

God Is The Rock

Preachers keep a steady hand when leading the flock
Keep your head to the sky because God is the Rock.
When you teach the Bible, teach it straight
Don't fall prey to the devil's bait
Be ware of people who claim the keys to heaven's lock
Because if you are in the faith, you would know that God is the Rock.
Now don't fall prey to the devil's lair
Trust in your Lord because he's always there.
God is the Rock.

God Is The Answer II

When the burdens of life seem to be a heavy **load**
I find solace in my **Lord's abode.**
God is the answer
When money is tight and you can't find a **job**
When the bill collectors are at your door like a **mob.**
God is the answer
God *comes to us as the answer to* **prayer**
If you want a friend, he's always **there.**
When a broken marriage leaves you in **despair**
Just keep the faith and put your burdens in **Gods care.**
God is the answer
So don't fret when life gets out of **hand**
Because your problems will be solved when you make **God** *your main* **man.**
God is the answer

Luther

Dionne Warwick told us, "Giving Up Is Hard To Do"
*Except when you have **Luther Vandross** singing to **you**.*
*Music had gone from smooth crooning to rock and **such***
*When **Luther** exploded with "Never Too Much".*
Luther** told us that when you are **alone
Your "House Is Not A Home".
Before you write your honey that "Dear John Letter"
Remember when it comes to love there's "Nothing Better".
Luther's** creative control of his career shows guidance from **above
He, through his consistent efforts, has made himself the "Doctor of Love".
Luther** told us love was not such a hard **chore
*Just adhere to the rules because you "Don't want to be a fool **anymore**".*
*Life is so full of ebbs anb **flows***
*But **Luther** gave us insight with "Heaven Knows".*
*May **God** continue to bless **Luther** with guidance from **above***
Because for millions, he is special and not just "Any Love".

To My Baby

*You came to me as though you were on a **cloud***
*You had the look of an angel that made your **Lord proud.***
*You entered my life on a very dark **day***
*You changed me forever in your own special **way.***
*Our Souls connected as though we had known each other forever and **ever***
*Our love for each other will go on forever and **ever.***
*I am you and you are **me***
*For all of the world to **see.***
*My thoughts are in your head and yours are in **mine***
*We'll always be together because we are one of a **kind***
My Baby** and I will be together even when we're **apart
*Because we are always together in each other's **heart***
*Thanks for being **My Baby** and don't ask **why***
*I know that we will love each other until the day we **die.***

Dedicated to my special lady.

God Is Enough

*Our young people have lost all **hope***
*Walking around with their bodies full of **dope.***
But God Is Enough
*Women put all their trust in the hands of a **man***
*When the man leaves they never **understand***
God Is Enough
*You go through life looking for **thrills***
*But if you are patient your **Lord** will fill the **bill***
God Is Enough
*When your mind is plagued by the problems of **today***
*If you would look to the **word** you would know that **God** is the **way,***
God Is Enough
*So for those of you who think that life is so **rough***
*Just hold on to faith because **God Is Enough.***

God Is Always There

When you are all alone and on the brink of despair
Keep your head to the sky because God is always there
When your best laid plans seem to fall apart
Just stay in the spirit and keep God in your heart.
God is always there
When the going gets tough and you are out of control
Just hold on to the faith and God won't let you fold.
God is always there
So carry on as you may, but always share
With the knowledge that if you are in the faith,
God is always there.

Q
(Quincey Jones)

*Since he was a child, **Q's** life was always guided by **fate***
*becoming best friends & being inspired by a young **Ray Robinson,**, the*
*future **Ray Charles**, one of soul music's **greats.***
Q** was discovered by **Lionel Hampton** and brought into his **band
This was the first step in the journey that would make him the great music
man.
*Traveling with **Hampton** would expose **Q** to the **New York** night **life***
*He would see first hand the daily toils in the 1950's of suffering and **strife.***
Q** went on his own and started doing movie **scores
*He punctuated his soulfulness by producing a monster hit for **Leslie Gore.***
*Producing the music for **"Sanford & Son"** and other TV shows Q brought*
*pizzazz to the small **screen***
*Q produced ghetto sounds that were lean and **mean.***
*Despite all his success, his greatest challenge lied **ahead***
*His meeting with **Michael Jackson** on the set of **The Wiz** again turned his*
head.
*Q as always again took the **ball***
*Producing **Michael Jackson's** smash album **"Off The Wall."***
*In the midst of all this activity, Q suffered a near fatal **aneurysm***
*He realized that time is precious, so he changed his previous **mannerisms.***
Michael Jackson's** record breaking album **"Thriller"** was his next **project
*Q's production skills shocked those who thought they knew what to **expect.***
Q next produced, with the music world's elite, the greatest selling single in
*history, **"We Are The World"***
*To show his concern for **Africa's** starving boys and **girls.***
*With the greatest selling album in history, **"Thriller"** behind him Q along*
*with **Michael Jackson** followed up with **"Bad"***
*To show that despite his previous success there was still more success to be **had.***
*Other artists flocked to **Q** so he decided to go **"Back On The Block"***
*With the amazing success of songs like **"Secret Garden"**, he showed that he*
*was not an ordinary **jock.***
*May **God** continue to bless **Q** because he has made his **point***
*To be the best that he could be as exemplified by his latest production,"**Juke***
Joint."

The Newly Controversial Louis Farrakhan

Minister Farrakhan's grand opening of the new **Salaam Restaurant** in **Chicago** has produced great **elation**
From all elements throughout the world's black **nation.**
The spify multi-million dollar restaurant was opened entirely **debt-free**
As an indication as **Minister Farrakhan** says, of what **Allah** wants us to **be.**
Minister Farrakhan's revolutionary move made him the object of vicious **attacks**
by **reactionary forces** determined to hold the **black man back.**
The Chicago Tribune opened up against **Minister Farrakhan** with a three page **spread**
with issues involving unrelated buisness problems that most people thought were **dead.**
The newspaper was probaly under pressure from white restaurants **downtown**
because **Salaam** is the best resturant anywhere to be **found.**
Most opposing groups really didn't worry about **Minister Farrakhan** as long as he was talking the **talk**
but with the purchase of *farmland* and **Salaam** he showed that he also walks the **walk.**
Minister Farrakhan has become constroversial by showing black people that **Allah** is all you **need**
It is up to us to throw off our **mental shackles** and follow his **lead.**
Minister Farrakhan is controversial because he goes against the grain, but what really sets him **apart**
Is his complete belief in the **power of God.**

The World In Black II

*Colin Powell's veiled attack on speeches by **Khalid Muhammed** as causing **black** people **harm***
*Produced indignation among **black** men who are sick of this professional **Uncle Tom**.*
*This brilliant man who could have given guidance and showed **Howard's** graduates the **way** Proved that despite his retirement, he's still a flunky for the power structure **every day**.*
*Let's hope with **Black** leabership in **South Africa,** economically, **blacks** will be **included***
*And it's not just show without substance and **blacks** are again **deluded**.*
*In **America, Indians** have reservations while **blacks** have the **ghetto***
*Despite our brilliance, without our own land, we are on a life boat with no place to **go**.*
*The assassination attempt on **Dr. Khalid Muhammed** after his emergence on the world **stage***
*Showed that 29 years after **Malcolm X's** death, we have not come of **age***
*And despite our rhetoric, the brothers took him off the **Final Call's every** page.*
*The **white** establishment will never accept a **black** leader not under their **control***
*So the men of the **Nation of Islam** are unacceptable because they are independent and **bold**.*
*So let us all come together before it's too **late***
*To lead our people to complete freedom and autonomy as part of our **fate**.*

The Soul of J. B.
(God Father of Soul)

*James Brown started his career by shining other people's **shoes***
*In time, he became the **King of Rhythm and Blues***
*His concern for the youth showed a heart of pure **gold***
His dedication and persistence to our struggle, earned him designation as
*the "**Godfather of Soul**".*
*At a time when **Martin Luther King, Jr.** was doing for us all he **could***
*J. B. gave us hope with "**I Feel Good**".*
*James laid the blueprint for future stars like **Michael Jackson** and **Prince***
*on how to be a **superstar***
His organizational skills were copied by all artists on their way to becoming
mega-stars.
*James Brown "**the hardest working man in show business**", was a*
*favorite of all the **girls***
*He showed the **Women's Liberation Movement** that despite their progress,*
*"**It's A Man's World**".*
*James told the youth that if they're messing up, they might as well **confess***
*Because your old "**Papa Don't Take No Mess**".*
*J. B.'s music was always on our **minds***
*He blew us out with "**There Was A Time**".*
*When the fad of the youth is "**Everybody Chilling**"*
*J. B. kept our focus with, "**I Got The Feeling**".*
*J. B. told us that despite all this mass **hysteria***
*There is nothing better than "**Living In America**".*
*James was there for us when he was **number one (1)** and on **top***
*Not like so many other stars who come to us only after they **flop**.*
*J. B.'s subsequent incarceration was like a death in our **community***
*His only crime was that he promoted **Black Unity***
*The rappers used the music of **J. B.** as their **foundation***
*His music again gave direction to a new **generation***
*"**Universal James**" shows this "**Georgialina**" at his **best***
*Because **J. B.** with his concerns, shows that like "**Papa He Don't Take No***
***Mess**".*
Long live the Godfather of Soul.

Lionel Ritchie

*Lionel's parents realized that at an early **age***
*That their son would one day dominate the **musical stage***
*Lionel's **grandmother**, a pianist, had a great influence on his **life***
*Her strength would carry him when his life would be full of turbulance and **strife***
*As a student at **Tuskegee University**, Lionel became an original **Commodore***
*With songs like "**Machine Gun**", they made everyone get on the **floor***
*All of the **Commodores** were muscians and songwriters, but **Lionel** was the **best***
*His songs like "**This Is Your Life**" and "**Easy**" are what separated him from the **rest**.*
*Lionel collaborated on songs like "**Zoom**" and "**Brickhouse**", but he still carried **on***
*Producing other smash hits, "**Three Times A Lady**" and "**Sail On**".*
*Through **Lionel** had written the first major hit for the **Commodores**, "**Sweet Love**"*
*He said goodbye to the **Commodores** by writing "**Lady**" for **Kenny Rogers** and his duet with **Dianna Ross**, "**Endless Love**".*
*Lionel went solo and was immediately a **superstar***
*With an album that featured numerous hits, including my favorite "**You Are**".*
*Lionel, with old producer, **James Casrmichael**, produced the second greatest selling album in history, "**Can't Slow Down**"*
*Lionel became the biggest star this side of his old friend , **Michael Jackson** anywhere to be **found**.*
*With wife, **Brenda** at his side, as his favorite **girl**,*
*He along with **Michael Jackson**, composed for starving people the greastest selling single in history, "**We Are The World**".*
*Just when **Lionel** was on top, his life fell **apart***
*He and **Brenda** had **a marital altercation** that really broke **Lionel's heart***
*Despite their dest efforts, their marrige was not to **be***
*So they decided to divorce, therefore making each other **<u>free</u>***
*Lionel in spite of himself, is still being guided from **above***
*With the birth of his new child, **Lionel** knows that "**Jesus Is Love**".*

Reflections of NCCU
"The Greatest University In The World"

Earlie Thorpe holding down the fort
Caulbert Jones and others giving their support.
This was the history department during the late 60's at NCCU
They showed you historically that if you wanted to progress what you must do
"You can never use the white man to your advantage", is what Caulbert Jones use to say
And Dr. Brewer through his eloquent showed us in his book, "The Conferate Negro", that Lincoln's freeing the slaves was only a myth because it didn't happen that way
Mrs. Robinson telling us to be the best that we could be
Dr. Helen Edmonds implying us to study all of the world's history
Dr. Thorpe telling us that a "Christian is one who chooses to exude love"
And showing us by example that once you get the world's Knowledge, you had to get guidance from God above.
Mrs. Farrison in and out of class, monitoring our English diction
Showing us that it is either correct, or just a lot of fiction
Dr. Cecil Patterson brightening everyone's day with a smile
Keeping our concentration when Mr. Ruffin drove us wild
Caulbert Jones, a student of Dr. Ralph Bunche, in Africa Studies, was the best of them all
He taught us that despite all our obstacles, we had to stand tall.
Many thanks to Dr. Thorpe and the history department for making our stay at NCCU so great
And showing us that education and compassion are a perfect mate
Thanks to Reverend Eaton for telling me to put together a B.S.U. Basketball Team
And letting me be player-coach on 2 B.S.U. state champions really made him gleam.
Memories of telling NCCU football quarterback "Sweet Man"(Clifton Herring)he should try basketball too.
Never realizing that later, he would be the high school coach of Michael Jordan, the elite of pro-basketballs "Who's Who".

Dedicated to the boys-Bruce Bridges, Harrison Davis, Jimmy Jones, Bobby Williams, Roderick Hodges, Clifton Herring, Holloway, Joe Harrell, Allen Reddish, Ronald Harding, Doug Wilkerson, Franklin Tate, John Patterson, and all the rest of the crew.

Farrakhan Today

Whether its Michael Jackson or Ben Davis in trouble Minister Farrakhan is there
because he realizes through experience that for black people the system is never fair.
Allah is Minister Farrakhan's inspiration and guide
As he continues spreading the teachings of the Honorable Elijah Muhammad and promoting black pride.
Through our collective efforts, the Nation of Islam has reacquired thousands of acres of farmland
Minister Farrakhan has shown us that black unity and economic development go hand in hand.
The "powers that be" want Minister Farrakhan to moderate so he can be brought into the so-called mainstream
But Minister Farrakhan with his brilliant articulation of black empowerment, shows them this is only a pipedream.
The Savior's Day Conference in Ghana was the fulfillment of the Honorable Elijah Muhammad's vision
The unity of blacks in Africa and America was a divine decision.
Religious detractors, Islamic and Christians claim that Minister Farrakhan is wrong and they are right
But a careful observation of them, shows that they are more concerned about being close to white.
Many of the critics of Minister Farrakhan, who want him to put the teachings of the Honorable Elijah Muhammad on the shelf
Have a severe case, unknown to them, of hatred of self.
Minister Farrakhan's counsel and support of Marion Barry, put him back on top
Showing that if you have the Minister's support, you are impossible to stop.
May God bless Minister Farrakhan as he leads us to the 21ˢᵗ century, too
Because he makes religion relevant and shows us by example what we must do.

Reflection on Martin Luther King and The King Holiday

*Our children are taught that all our **civil rights** came through **Martin Luther King***
*Although he did a **monumental work** others played more **pivotal parts** in making freedom **ring**. The **Montgomery Bus Boycott** integrated the **public bus** but not **public accommodations***
*It was up to **four NCA&T freshmen** a few years later to light a fire in the **nation.***
*The **four freshmen**, inspired by their teacher's speech on **civil disobedience**, started the*
Civil Rights Sit-ins
*fueled by **Floyd McKissick's fire**, other students and civil rights **leaders** jumped in.*
King** and other **leaders** got in the **Movement** for **coordination** and **control
*Because the **"powers that be"** feared **black youth** acting so **bold***
*In the Montgomery Movement, **King** had the authorities by the **"proverbial balls"**, but he refused to expand the **goal.***
*The **Sit-in Movement** had legs whether or not **King** entered the **fold***
*It was the national coverage of the **Floyd McKissick** led **Sit-in** at **Durham's Howard Johnson** that led to **equal accommodations** in all of it's motels*
*The **Student movement** really for **blacks** rang out **the liberty bell***
*The **student inspired Sit-ins** would be used by **King** and the **SCLC** in Atlanta, Athens, and **pivotal Birmingham too***
*Despite all the **adulation's** given our **leaders**, it was our youth who showed them what to **do.***
*Be **joyful** and **celebrate** the **life of Martin Luther King** and the **King holiday***
*With the **knowledge** that **students** like; **Claudia Dixon, Burnis Lee Toomer, Andrea** and **Joycelyn McKissick** and **others**, showed them the **way.***

*Dedicated to the **Floyd McKissick, Rev A.D. Mosley**, and **my Grandfather, Leonard Lyon, Sr.***
*Special dedication to **Jeannie Lucas, Vivian McCoy**. **Douglas Burt**, and the **North Durham Community.***

James Baldwin

James Baldwin was a **preacher** at the **tender age of nine**
Years after his death, his words still blow our **minds.**
As a child, going to the library in the **White** neighborhood **James** was a victim of police **abuse**
Because a **Black** in a **White** neighborhood at night, was a "coon on the **loose".**
James' experience of being saved at an early **age,**
Would keep his life in focus later when he was on the world **stage.**
"Another Country" and **"Nobody Knows My Name",** would highlight the essence of **Black thought**
Baldwin put into words the battles that needed to be **fought**
"Giovanni's Room", showed his personal life **style**
His different orientation drove a lot of people **wild**
"Blues for Mr. Charlie" put the **Civil Rights Movement** in **focus**
He told the world the **Movement** had substance, rather than just being **hocus smocus.**
The great **Malcolm X** said that **James Baldwin's** words had **White** people **upset**
Of his encounter with the **Honorable Elijah Muhammad,** Baldwin called it **"My meeting with a prophet.**
"The Fire Next Time", would expose the world to the **Black Muslim Movement** of the **Honorable Elijah Muhammad** and **Malcolm X**
He told **America** that if they rejected the **Civil Rights Movement** the fire of the **Black Muslims** would be **next.**
For most of his life, In order to escape racism, Baldwin lived in Paris as an **exile**
He sought refuge because he felt the racist situation here was a little too **wild.**
The personal **James Baldwin,** responding to a letter from the then aspiring writer, **Alex Haley,** showed up at his **door**
He gave the future **"Roots"** author inspiration and advice and a whole lot **more.**
Baldwin was respected by **Malcolm X, Elijah Muhammad** and **Martin Luther** as **well**
Because he articulated brilliantly the **Black Man's hell**

Thank you **James Baldwin** for telling our **story**
May you rest in peace with all of **God's glory**

Kwame Toure' aka Stokely Carmichael

As a youth, **Brother Kwame** knew he would be **bad**
Because he unlike his peers was from the dynamic country of **Trinidad.**
Growing up in **Harlem** gave **Brother Kwame** a solid **foundation**
For his future endeavors that would shake the world and **nation.**
At **Howard University** the talented **Kwame** started to hit his **stride**
By inviting **Malcolm X** to speak and demanding the administrators show **Black pride.**
With the advent of the student sit-ins **Brother Kwame's** organizational skills began to **click**
With his being in on the formation of **SNICK.**
As a field worker in the **Mississippi Delta Kwame** was featured in **Life Magazine**
He showed through efforts that he would be there until freedom **ringed.**
Battling police and racists in **Greenwood, Mississippi** convinced **Kwame** that he could not be the movement's blossoming **flower**
So with brothers like **Willie Ricks** he reached for "**Black Power.**"
Three decades later this is still the order of the **day**
Unknown to a lot of our youth it was **Brother Kwame** who showed us the **way.**
Brother Kwame introduced the world to **H. Rap Brown**
His "**Burn, Baby Burn**" made **Rap** the most dangerous revolutionary anywhere to be **found.**
Brother Kwame became a citizen of the world and a diplomat from **Guinea** on the **African continent**
With his **All African People's Party**, he has exemplified the word **commitment.**
Thank you **Brother Kwame** you are the greatest in our **eyes**
Because despite the ups and downs of life you keep your focus on the "**prize.**"
"God Bless Kwame Toure'"

Babyface
(Kenny Edmunds)

In his early life, **Kenny Edmunds** was in his own special **bag**
He entered our consciousness when he composed **Midnight Star's hit
"Slow Drag"**.
At this recording session, **Kenny** made connections with **L.A. Reid's** group
"The Deele"
This coming together for music lovers would later fill the **bill.**
Everyone in the group had a nickname including **Kenny's Kenny E.**
But **Bootsey Collings** blurting out **"Babyface"** at their first meeting, Gave
him the name that he would forever **be.**
The Deele's first album was probuced by **Reggie Callaway of Midnight Star**
For the seconb album, with the absence of the **Callaway's, L.A. and
Babyface** were forced into production and it would take them very **far.**
The **Whispers "Rock Steady"** was the first outside project for this new
production **team**
This excellent collaboration made music fans **beam.**
Follow-up hits with **Paula Adbul, Karen White, Bobby Brown** and other
artists for **Babyface** didn't fill the **bill.**
So he followed with his own album which featured the smash hit, **"Whip
Appeal".**
Their production success led to the formation of **Laface Records in Atlanta**
With the development and success of new acts like **Toni Braxton** and
TLC, they showed that they were first rate and not anyone's second
banana.
Being a singer, songwriter, producer, and executive proved for **Babyface** to
be a heavy **load**
So due to private discrepancies, one of the **last productions of the L.A.
and Babyface team with best friend, Darryl Simmons** producing Telvin
Campbell's, **"Can We Talk".**
"For The Cool In You" shows that **God** continues to bless him as he keeps
it **steady**
And further enhances his statue with his lastest production, **Telvin's "I'm
Ready"**

Sam Cooke

*Sam entered our lives, the love of every **girl***
*His voice leading the **Soul Stirrers**, captured the gospel **world.***
*With the Soul Stirrers, he became a gospel music superstar **too***
*So **he** decided to take the love of Jesus into the **Secular Music** to show that
there was nothing **he** couldn't **do.***
*His early efforts didn't click, so the record company decided he was a **flop***
*So **he** was released from his contract before his last song, **L.C. Cooke's**
"**You Send Me**", went to the **top***
*This act of fate helped **Sam** gain total control of his **career***
*His songs told of joy and pain for all to **hear***
*"**Another Saturday Night**" was made for the brothers who liked to **hang***
*He showed us the other side of life "**Working on the Chain Gang**"*
*Despite **his** tremendous success and nice family and **wife***
*Sam's downfall was that **he** wanted more gusto from **life***
*Sam lived **his** life hanging with friends like **Muhammed Ali** and in the fast
lane*
*He decided he had nothing to lose but everything to **gain***
*Sam lost his life in an argument over a **girl***
*It was ironic that one of his greastest hits was "**What A Wonderful
World**".*
*Musically, **Sam** seemed to know that he was going back to where he came
from*
*With the release of his last song "**A Change Gone Come**".*
*Thank you **Sam** for leaving your musical legacy **behind***
*Because your beautiful music is one of a **kind.***

Soul of Michael Jackson
(Inspired by BJ)

Throughout his musical career, **Michael** has been **misunderstood**
Because the price of fame at such a young age stole his **childhood**
The **Jackson 5**, became the biggest group in **history**
Through it, all the lead singers **Michael** has always been a **mystery.**
On stage, the **Jackson 5**, drove the fans **wild**
In life, **Michael** felt that being unable to have childhood fun, he was a
deprived **child.**
At **Motown**, **Michael** was just a part of the **machine**
They didn't encourage creativity but wanted him to just entertain and **sing.**
The song "**Ben**" highlighted a highly sensitive **M.J.**
But insightful songs like this were not the **Motown way.**
Established artists like **Marvin Gaye** and **Stevie Wonder,** had to fight for
creative **control**
So **Papa Joe** decided that when their contract expired, they would leave the
fold.
All of the **Jacksons** went to **Epic Records,** except **Jermaine**
This act caused all of his family a lot of **pain.**
At **Epic**, the **Jacksons** gained creative **control.**
And **Michael,** with his mind running creatively, would be something to
behold
Michael's breakthrough album was "**Off The Wall**"
Before he was through, all **sales records** would **fall.**
"**Thriller**" would be the greatest selling album of all **time**
His success would make him one of a **kind.**
With his musical success, **Michael** saw it as his mission to help **all the
children of the world**
His support of the "**Make A wish Foundation**", put smiles on the faces of
thousands of **boys and girls**
Michael gave millions to schools and organizations, not for publicity but
from the **heart**
His **generosity of spirit** is what sets him **apart.**
The conspiracy to bring down **Michael,** was caused by greed and elements
of the **L.A.P.D.**

But by **God's** graces, **Michael** survived and is happily married to the
King's daughter, Lisa Marie.
Michael, with God in your heart,,may you always be on **top**
Because you are "**Bad**" and "**Dangerous**" and impossible to **stop.**
God Bless M.J.

The Temptations
(Eddie, Otis, Paul, David, and Melvin)

The **Temptations** *were the combination of two groups,* **Otis Williams and the Distants and the Fabulous Primes.**
This coming together would set the mold for future groups of all **times**
Otis Williams, Melvin Franklin, and Eldridge Bryant *came from the* **Distants**
Eddie Kendricks and Paul Williams of the Primes *made the group lethal at the first* **instant.**
Paul, *a great dancer, taught the new group how to* **dance**
He told them that in addition to singing, they were selling **sex and romance.**
Fueled by **Paul Williams'** *showmanship, the* **Tempts** *put on the greatest show at* **Motown**
They became the best group without a **hit** *anywhere to be* **found.**
Songs like **"I Want A Love I Can See", and "Farewell My Love",** *though not major hits set the* **mold.**
For later hits from these true masters of **soul.**
The **Tempts** *made their* **Apollo** *debut as backup singers for* **Mary Wells**
This brief appearance fore shadowed the small sprinkle that would turn into musical **hail.**
The **Tempts** *were talented but the puzzle was* **incomplete**
The missing part came when **David Ruffin** *joined them on stage with his dancing* **feet.**
Internal bickering forced **Elridge Bryant** *from the* **group**
So the addition of the impressive **David Ruffin** *completed this* **musical loop**
The **tempts** *had been with* **Motown** *for* **4 years by 1964** *without a* **hit**
So **Norman whitfield** *initiated a song writing contest for them that everyone* **bit.**
Motown's *president,* **Berry Gordy,** *thought the song he wrote was the* **smash**
But **Smokey Robinson** *told* **Berry** *his song would make* **Berry** *throw his in the* **trash**
Smokey's *song,* **"The Way You Do The Things You Do",** *would introduce the* **Temptations** *to the* **Musical World**
They would follow this up in a big way with **Smokey's classic number one hit "My Girl".**

Other Smokey songs, "It's Growing", "Since I Lost My Baby", "My Baby","Get Ready", and others established the Tempts as the best
Despite other groups best efforts, The Tempts were light years ahead of the rest.
David, Eddie, Otis, Paul, and Melvin gave us pride in being black
After the Temptations, the Black Man would never again be held back.
After numerous hits and personal changes, The Tempts continues to roll on
But the legacy of what they meant will be with us long after they are gone.
God Bless The Classic Temptations.

Dedicated to the late Eddie Kendricks, David Ruffin, and Paul Williams.

Special dedication to Otis Williams, Melvin Franklin, Dennis Edwards, and the other Temptations.

Special recognition: Writer/Producer, Smokey Robinson

Rev. Ben Chavis
(Champion of Freedom)

*This warrior came from the **North Carolina town of Oxford***
*He would dedicate his life to fighting for his people and serving the **Lord***
*He first gained notoriety as a member of the **Wilmington Ten***
*The **"powers to be"**attacked him because they saw a **New Martin Luther
King in Ben***
*Ben and the rest of the **Wilmington Ten**, after a highly publicized trial,
were sent to **jail***
*Because the power structure was determined to make **Black Leadership
fail**.*
*While in a **North Carolina prison, Ben's** appendix burst and it made him
cry*
*The authorities drove him 75 miles to a hospital because they wanted him
to **die***
*Ben was exonerated after being in prison for **four years***
*He had survived with **God's** help, despite all his inner **fears***
*God was his salvation as he returned to his post with the **United Church of
Christ***
*His inner vision let him know that if you fight for freedom, you will have to
sacrifice.*
*Ben became a **Newspaper Columnist** and a **National Speaker***
*He told **blacks** if they didn't organize, their lives would be **bleaker***
*Ben's life was controlled again by divine **intervention***
*He was elected **Executive Director** at the **NAACP Convention***
*Ben immediately convened a **gang Summit** to address the problem of
Urban life*
*He was trying to being peace to all this madness and **strife.***
*Convening the **Black Summit** was Ben's **major accomplishment***
*He got the **Congressional Black Caucus, Farrakhan, Jesse Jackson** and
others together despite the mechanisms of the **government**.*
*This **Summit** set the stage for his **demise***
*The settlement for the harrassment as an excuse, was only a **guise***
*Ben acclomplished what **all black leaders** for years have tried to **do***
*When he convened **black America's, Who's Who***
*Ben's dismissal from the leadership of the **NAACP** was a bitter **pill***

*His only crime was that he did **God's will.***
God bless Ben Chavis.

(Consultant-Fahim Knight)

Jimmy Jam and Terry Lewis
(*James Harris III*)

Jimmy and Terry became spiritual brothers at a very early **age**
This union would prove productive and dominate the world's musical **stage.**
Music and common interests are the things that bound them **together**
They learned early on they they were birds of the same **feather.**
Jimmy and Terry, along with **Morris Day, Jesse Johnson, Jellybean,**
Jerome, and Monte Moir, became members of the **Time**
Their music was uplifting and soothing to the **mind.**
Though the **Time** was a jam, *Jimmy and Terry* had bigger fish to **fry**
So they started producing hits for the **S.O.S. Band** on the **sly.**
The phenomenal success of **Prince and the Time** had the **Minneapolis**
groups on the **move**
And the upcoming movie, at the time, **Purple Rain,** would establish
Minneapolis' own special **groove.**
Working with the **S.O.S. Band,** *Jimmy and Terry* were late for a **flight**
And **Prince** basking in glory, gave them the boot and told them to get out of
his **sight.**
Prince probably felt that he was putting their musical aspirations on the
shelf
But *Jimmy and Terry,* with their backs against the wall, decided to do for
self.
Starting **Flight Time Productions** at the time when the **Purple Madness**
was on **top,**
Many of their friends thought they were doomed to **flop.**
Cherelle and Alexander O'Neal were some of the first artists for the new
team
The hits that followed, showed the music world that they had the winning
gleam.
Producing hits for **British** acts, **Human Nature and George Michael,**
enhanced their position **too**
They showed that musically there was nothing they couldn't **do.**
Despite their great efforts, they were still part of a musical fish **bowl**
But this changed when with **Janet Jackson,** they reached for "**Control**".
The album was a monster smash that sold 10 million **plus**
It brought the team of **Jam and Lewis** from the middle to the front of the **bus.**

In the middle of all of this, Janet Jackson activity,
Jam and Lewis gave New Edition a smash album, and showed Johnny
Gill how to "Rub You The Right Way" and gave Ralph Tresvant
"Sensitivity".
This subsequent success produced great elation
But Jimmy and Terry kept the fire going with Janet's super smash,
"Rhythm Nation".
Jam and Lewis reunited with Morris Day to produce his smash hit "Fish
Net"
This led to the subsequent Time reunion that music lovers would not
forget.
The reunited Time fueled by the success of Jam and Lewis, starred in the
movie,
"Graffetti Bridge" and produced a hit song
This silenced the doubters who thought that a reunion was wrong.
A confident Terry Lewis got "Romantic" with his new wife, Karen White
Jimmy Jam's recent marriage to Lisa, shows that love is alright.
Jam and Lewis company, Perspective, have the sounds of Blackness being
"Optimistic"
And the soulfulness of the smash album "Janet" shows that Jimmy and
Terry are realistic.
May Jimmy and Terry continue to be guided from above
And saying in their music the greatest force in the universe is love.

O.J. Simpson

Out of the projects of **San Francisco, O. J. Simpson came**
He would rise from poverty to achieve fortune and **fame.**
O. J. like his cousin, **Ernie Banks,** had a pleasant **disposition**
This would serve him well in all his fields of **competition.**
O. J., along with best friend, **Al Cowlings,** excelled in sports in high **school**
And though he was considered a brute, he was not anyone's **fool.**
O. J. with his charm, took **Al's** girl friend, **Marguerite**
She fell for **O. J.** because he was delightful and **neat.**
After starring in **junior college, O. J.** went on to **Southern Cal**
He brought along Marguerite and his best friend, **Al.**
At **Southern Cal, O. J.** became the greatest **running back** ever, winning **All
American Honors** and the **Heisman Trophy too**
His charisma and athletic ability made all of **America** give him his **due.**
After his stellar career at **Southern Cal, O. J.** was the number one pick of
the **Buffalo Bills**
The fans packed the stadiums waiting for **O. J.** to give them **thrills.**
In the unimaginative offense at first, **O. J. flopped**
So the fans thought that this was just another college player who couldn't
make it to the **top.**
 O. J. had his doubts until the **Bills** hired **Lou Saban**
His first statement to **O. J.** was, **"I'm going to make you the man".**
Coach Saban's offensive schemes let **O. J.** run **loose**
Fans all over screamed **"Miami has the oranges, but Buffalo has the Juice".**
With **Reggie** leading the way, the **Juice** was the **best**
His becoming the **NFL's** first 2,000 yard runner, put him virtually **light
years** ahead of the **rest.**
In his personal life, **O. J.** had his first three children with wife, **Marguerite**
As he became more famous, in marriage he met **defeat.**
The athletic ability of **O. J.** was diminishing and he was getting **old**
Looking to his future, the **Juice** found a **new mate** in the lovely **Nicole.**
After the **tragedy** of the **death** of his **daughter** and **soul searching,** the
Juice gave
Marguerite a divorce
For his future, the Juice made Nicole his **choice.**

*O. J., like a lot of **Black men,** probably felt that the **measure of success** was having a **white wife***
*Therefore, they could distance themselves from the prevalent racial **strife.***
*The Juice became a **popular actor, sports broadcaster, and a Hertz Ad man***
*Being successful without **Black consciousness,** has serious consequences, if you really **understand.***
*O. J.'s relationship with **Nicole** had both public and private **sides***
*With the tragedy of the deaths of **Nicole and Ron Goldman,** its up to the **Jury to decide.***
*Hopefully **O. J.** didn't commit this heinous **crime***
*Because the persecution of prominent **Black men** is popular in these **times.***
*Regardless, whether he's innocent or guilty, the truth will come **out***
*And the **perpetrator** will be revealed without any **doubt.***
God bless the Juice.
Dedicated to B. J., who makes my words come alive.

The Soul of Marvin Gaye

Marvin was a "Stubborn Kind of Fellow" for whom life was not very **kind**
His music, a decade after his death, still mesmerizes the **mind.**
Marvin was an astute musician who played drums on **Motown's** *fist*
number one hit **"Please Mr. Postman"**
With songs like **"Hitch Hike"** *and* **"Ain't That Peculiar".** *Marvin was*
the dream of every **fan.**
Playing the piano at **Motown, Marvin** *was the dream boat of all of*
Motown's young girls
His marriage to **Anna Gordy** *really shook up their* **worlds.**
Despite his huge success with songs like **"I Heard It Through The**
Grapevine". **Marvin** *was on a self-destructive* **course**
Self-destructive demons lurked within him and his marriage ended in
divorce.
He found a soulful soul mate in the lovely **Tammi Terrell**
After several monster hits, **Tammi** *suffered a brain tumor and collapsed in*
Marvin's *arms on stage and again his life was* **hell.**
Marvin *went into exile and just wanted to be left* **alone**
But two of his **Motown** *friends,* **Al Cleveland,** *and* **Renaldo Benson,** *gave*
him a song they were working on called **"What's Going On".**
They bugged **Marvin** *for a month to listen to the song and he finally saw*
the **light**
And **Marvin's** *collaboration made the song* **"Dynamite"**
Marvin's *production of* **Motown's** *first concept album,* **"What's Going**
On" *was* **Motown's** *biggest seller* **ever**
It gave meaningful messages that affected peoples life's rather than just being
entertaining and **clever.**
"What's Going On" *made* **Marvin** *the spokesman for a whole* **generation**
His **"Mercy, Mercy, Me"** *became the enviromental movement's* **salvation.**
Marvin's *music was used with a story to* **tell**
He couldn't sing about pennyante things when the whole world was going to
hell
"Distant Lover" *highlighted* **Marvin's** *next* **tour**
His love for **Jan** *provided his mind with a temporary* **cure.**
Marvin *gave us the medicine when your baby wants to be left* **alone,**
Just hold her in your arms and whisper **"Let's Get It On".**

*Marvin's last tour was punctuated by personal problems and cocaine **use***
*His life long demons were determined to stop this golden **goose.***
*Despite his personal troubles, **Marvin** saw a need to stop the **killing***
*He told us the perfect solution was **"Sexual Healing".***
Marvin's** life ended on April Fool's Day when he was shot by his **dad
*These circumstances for us made his departing so **sad.***
*Thank you **Marvin** for sharing your soul with us before death gave you your **release***
*To be with your father in heaven and your soul at **peace***
God Bless Marvin Gaye.

The Big "O"
(Otis Redding)

Otis Redding, inspired by Little Richard, started his musical career as a driver For Johnny Jenkins and the Hilltoppers
He continued on until he became Soul Music's Big Bopper.
Driving Jenkins to Memphis for an audition, Otis decided to have one for himself
After one audition Otis was signed up and Jenkins and the boys were left on the shelf
Otis' success put his relationship with his friends in a serious bind
But they recognized his talent when he hit with ("These Arms Of Mine").
Otis became the anchor for the Memphis based Stax
His Influence helped push fellow singers to reach their max.
With Carla Thomas, they put out the album, "King and Queen"
The album was spiced with sexuality, but the product was good and clean.
"I Been Loving You Too Long" shows an Otis full of love's exasperation
He shows his soulfulness with the Rolling Stones' "Satisfaction".
"Try A Little Tenderness" by Otis was the epitome of Soul
A little nudging by Otis, caused Aretha Franklin to turn his song "Respect" into permanent gold.
Otis' compostion "Sweet Soul Music" sent Arthur Conley's carreer to the top.
Other acts feeding off Otis went on to success instead of becoming flops.
Otis' success at the Monterrey Festival had him on his way
But his spirituality told him he was going to his eternal home in "Sitting On The Dock Of The Bay".
A plane crash took Otis, one of soul music's brightest lights
but the musical legacy he left behind has made him alright.
Long live the Big "O"

Marcus Garvey

Out of Jamaica Marcus Garvey came to this land
To bring forth the upliftment of a people and restore Blacks as the Worlds
Leading Man.
He was a "Master Printer" in Jamaica where for fellow workers, he made
his first stand
His fellow workers gave in and Garvey lost his job, therefore, he had to flee
his homeland.
In about 1910, he went to London where he went to work for the Muslim,
Duse Muhammed Ali
Who taught him the true nature of the Black man and his ultimate destiny.
Duse Muhammed Ali told Garvey that "Black men were kings when
whites were savages living in caves"
So Garvey realized his destiny and the people he had to save.
He came to America to find Booker T. Washington, the Sage of Tuskeegee
When he found out that Booker T. was dead, he realized that the Black
Man's fate was his destiny.
Speaking from the pulpit in New York City, with the West Indian accent,
he was booed offstage
He realized that if he wanted to lead, his voice would have to come of age.
Listening to black preachers in Harlem, Gravey studied their technique
He realized if he was to reach his potential, he would have to be chic.
The Universal Negro Improvement Association would be the name of
Garvey's organization His motto "Up You Mighty Race" would resurrect
the Black man in the world and nation. Garvey, like Booker T., before
him, taught Blacks to do for self
And quite being lackeys for white people to the death.
A powerful orator, Garvey had uniformed men and women groups and
staged elaborate parades
He started factories and businesses to show that his organization was
substance rather than just a charade.
His organization had chapters world wide and connections in Africa, too
He put legs on his "Back to Africa" theme by purchasing ships to show it
was nothing he couldn't do.
His negotiations with Liberian authorities secured him fertile African Land
But the international "Powers that be" realized he was getting out of hand.

British and *French* authorities expressed to the **US Government** that **Garvey** must be **stopped**
So the **US Government** with **J. Edgar Hoover,** used infiltrators to make his business deals **flop.**
His "*Africa for the Africans*" had international **implications**
The **Irish Republican Army,** fighting the **British,** used his words and personal cables for **motivation.**
He was convicted of a trumped up mail fraud **charge**
Because of a **black** condition he wanted to **dislodge.**
The father of **Malcolm X,** and **Elijah Muhammed** were also part of his **movement**
Garvey refused to accept black ineptitude as set in **cement.**
Garvey was deported after his stay in **jail**
Because he wanted the **Black** man strong and never to **fail.**
Garvey's principles were incorporated in the **Nation of Islam** and other **Black organizations**
They rose up the **Black** man and cast away the **miseducation.**
Garvey died in **London** in **1940,** never regaining his former glory, but a proud **man**
Future leaders, **Malcolm X, Jomo Kenyetta,** and other dynamic leaders would be able to go forward because of Garvey's **stand.**

Today's Black Man (1994)

*We were brought to **America** as desired **property***
*To **work** and serve the **master** was our **destiny***
*Our **forefathers** never needed a **green card***
*Because we were **property** who picked **cotton** and **cleaned the yard***
*We parade around a **America** as **citizens** of this **country** and don't **realize***
*That to be a citizen, **you** or your **forefathers** must first be **naturalized.***
*The **present political establishment,** **courts, the police,** and the **tax system***
*were part off the **slave society, too***
Regardless of which way you go the slave mentality is in almost everything
*you **do.***
*The **Black man** must go from **freedman** to **free man***
*The basis of **true freedom is autonomous ownership** of land*
*Young men fighting over **colors** and thinking they are **hip,***
*Don't realize all of our ancestors were **one** in the holes of slave **ships***
*Prominent **Black men** like, **Charles Barkley,** looking to conservatives, like*
***Russ Limbaugh** to embrace,*
*Don't realize that the **basis of conservative theology** is **keep the Black***
man in his place.
Knowledge** is the **key** to our **salvation
*So put down the **drugs** and get and **education.***

Dedicated to the late Dr. Earlie Thorpe and Dr. C Eric Lincoln

The Assassination of Malcolm X
(In New York City)

Thirty years after the assassination of Malcolm X, the So-called
"Apostle of Hate"
His defense team, led by an establishment, Betty Shabazz, are making
accusations regarding his fate.
Minister Loius Farrakhan was a vital part of Malcolm X's life
Years before he met sister Betty, and she became his wife.
Malcolm X with Louis Farrakhan, was hated by whites and
establishment blacks as they went down the liberation road
Louis's music provided financial support and helped ease Malcolm's
load.
Malcolm's break with the Nation of Islam, made the brothers choose
sides
For Louis, being so close to Malcolm, this split sent his mind on a
tortuous ride.
The "Powers That Be" set back and fanned the flames
Former brothers in faith began calling each other names.
Allah's good will was taken out of circulation
Brother's began fighting each other and praying for their enemies'
damnation
Malcolm's break was due to God's will
He was preparing the way for Minister Farrakhan so he could fill the bill.
Betty Shabazz's implication that Minister Farrakhan was involved in
Malcolm's murder, still blows the mind
Because New York City is the home of murder and crime.
As I said previously, Malcolm was not killed by anyone's direction
It was because Allah had withdrawn his protection.
Malcolm, with police agents acting as bodyguards in early February
Of 1965, was forbidden to leave Paris France's Airport
Because the French had gotten news of his impending assassination
through intelligence reports.
Malcolm's non-search policy on that fatal day is presumed to have led
to his death
But there were government agents inside and outside the Audubon
Ballroom who were interested in his destruction and not his health.

Louis Lomax, the producer of "The Hate That Hate Produced"
documentary, wrote in 1967 "To Kill A Black Man" about Malcolm's
assassination and future attempts on M.L. King and what it takes
But before he could complete this subject, he rented a car with faulty
brakes.
Malcolm's greatest gift was the life he lived
He gave all he had freedom and had nothing else to give.

Reflections on the New South Africa

Nelson Mandela's presidential inauguration
Set off an abundance of world-wide celebrations.
This man, a fighter for human dignity, has been imprisoned for 27 years
But he kept the faith despite all his inner fears.
The South African people with leaders like Steven Biko and Sisulu,
should be commended for their fight against oppression
Because brutality against the Black population has become a White obsession.
The impetus for the new South Africa's march to be free
Started with Jesse Jackson's presidential Campaign of 1983.
Jesse Jackson, with the aid of Louis Farrakhan, invigorated people of color
on all of the earth's land
His entering world affairs by getting Syria to release the black pilot,showed
the potency of the black man.
Certain American blacks reflecting on the suffering of South African
blacks, cried crocodile tears
They conventually forgot that what South African blacks have suffered has
been suffered by us for over 400 years.
South African blacks said watching the police bulldoze their homes made
them want to throw a fit
But here in America, Whites have burned and bulldozed our homes for
years with us in it.
The rise of South Africa is a direct result of the Nation of Islam's rise
The emergence on the world's stage of Louis Farrakhan, brought forth
truth and opened our eyes.
The honorable Elijah Muhammed's representative, Minister Farrakhan,
became the most reputed black man world-wide
He showed the world's black population that you have nothing to fear with
God on your side.
Farrakhan's casette tapes were smuggled into South Afica in the early 80's
and got the people on the move
And from that time on, they could never bow to white leadership and were
in their own special groove.
Mandela was invited to Chicago by Whites because they thought he would
tell Minister Farrakhan that he was a disgrace

But after hearing **Minister Farrakhan** speak, he realized this was his
brother and they tearfully **embraced.**
Hopefully, the **Black South African** Leaders will realize that **Black
Americans** should be partners in the mineral resources **too**
Because we were **disenfranchised** in the slave trade and denied our
birthright and there was nothing we could **do.**
God bless the new **South Africa** strong and **free**
So she can grow strong showing the world what **Black Man** can **be.**

Robeson of Rutgers
The Odyssey of Paul Robeson

Before his epic life battles **had begun**
He realized the challenge of being **his** father's **son.**
His father taught him that a **Robeson** always had to be the **best**
This would be his inspiration in his future life **quests.**
Robeson's odyssey began as a student at **Rutgers** where he **excelled**
Despite the **segregation and discrimination, Robeson,** for his people
answered the **bell.**
Robeson became the **first Black All-American football** player and
valedictorian of his class **too**
He showed that with **God** as your anchor there's nothing you can't **do.**
After **Rutgers in 1918, Robeson** played in the **NFL** and attended
Columbia Law School
He showed through his accomplishments that **black** it doesn't make you a
fool.
Robeson, after **graduating with honors at Columbia,** went to work in a
New York law firm **too**
His brilliance in law impressed his peers, but the **wanton discrimination** of
the time caused him to **move on** because there other things to **do.**
The playwright **Eugene O'neal** launched Robeson's stage **career**
His booming voice would provide the mold for all future singers to hear.
Robeson was a major part of the **"Harlem Renaissance"**
His captivating presence impressed every **audience.**
His signature song **"Old Man River"** set the **mold**
For his future confrontations expressing his **soul.**
His film **"The Emperor Jones"** shows Robeson at his **best**
He displayed dignity at a time when **black people** only job was cleaning up
white people's mess.
Othello highlighted his stage **career**
As he became the **first black man** on stage to kiss a **white woman** and hold
her **near.**
Despite all his accomplishments in life his main focus remained on **blacks**
Every move he made was designed to fight white racist **attacks.**
The political Robeson became a man fighting injustice all over the **world**

His singing stopped the **Spanish Civil War** for a day so both sides could hear this special *"Black Pearl"*.

While living in London, The great **African** revolutionary **Jomo Kenyatta** was his house **mate**

With **W.E. Dubois,** he embraced **Pan-Africanisms** as part of the **Black man's fate.**

As a thinking man, he studied socialism to find it's powerful **allure** Relating this to his people, this might provide an economic **cure.**

Robeson's world travels and views after **World War II** upset the **powers that be**

This man's preaching for **African liberation** and against racial discrimination in **America** had the attention of the **world's family.**

He was brought before **Congress in 1950** and asked to defend his **stand** He refused to bow down and showed that he was not a flunky but a **strong man.**

For his stand **Robeson** was blackballed and his name was taken off the honors he had received including the football **All America lists** Because he refused to bend for the behinds they wanted him to **kiss.**

All his big **American** singing concerts were canceled but it didn't matter because he had **worldwide support** So the government followed this up by canceling his **passport.**

Fueled by vicious government propaganda **Blacks in Harlem** threw eggs and booed him **offstage.** The **Blacks** of 1950's had not come of **age.**

Robeson stilled remained immensely popular and his birthday was celebrated **worldwide** Because he stood up for principle and refused to **hide.**

He was a role model for **Martin Luther King, Malcolm X, Farrakhan,** protégés **Sidney Poitier** and **Harry Belafonte** and all the other black leaders of **today** He showed that if you stand up for principle you will be treated the same **way.**

Robeson's views are exposed in his book *"Here I Stand"* This is my tribute to this monumental **man.**

Black Christmas 1968

*White businesses downtown refused to hire **Blacks** as **clerks***
*They insinuated through their actions that we as a people were nothing but **jerks**.*
*With radical leaders of the time, **Ben Ruffin & Howard Fuller**, the movement took **shape***
*They told us to withhold our **Christmas** shopping to show that we were men and not **apes**.*
Martin Luther King, Jr.** had gotten killed earlier that **year
*So not too many **blacks** were in the mood for **Christmas** cheer.*
*The deaths of **King** and **Robert Kennedy** had a definite impact on the **movement***
*It made us stand up on principle and refuse to **relent**.*
*We put picket lines on **Main Street** from Roses down to **Kresses***
*And as **B. B.** wrote at the time **"our beautiful Black Sisters couldn't get enough of Lerner's dresses"**.*
*This was the movement that brought **black** consciousness into **Christmas** and showed us the **way***
*To foster in **Black Afrocentric** celebrations like **Kwanzaa** on the **Christmas holiday**.*
*We as a people, stood fast until all the barriers fell **down***
*We decided to destroy the last vantages of **Jim Crow** that were still **around**.*
Malcolm X University** and **U.D.I.** were outgrowths of this **movement
*It symbolized **Black** rejection of the So-call white **establishment**.*
*The **Black** churches of **Durham** sponsored and gave us our **inspiration***

*For our fights for dignity and against racial **discrimination**.*
*Celebrate your Kwanzaas and other **Black** celebrations **too***
*With the knowledge that as far as **Blackness** goes, we didn't wait for **Dr. Karenga** or others to tell us what to **do**.*

*Dedicated to the late **Rev. A. D. Moseley; Dr. Grady Davis, Rev. W. T. Bigelow**, and all the other **great Black ministers of Durham**.*

*Special dedication to some of our other **Black leaders** who have since sold us out **for a few pieces of Silver and a position**.*

*Consultant: Bruce Bridges, Author of the original **"Black Christmas"***

Dr. W. E. B. Dubois
(NAACP Leader)
Greatest Mind of 20th Century

Being born in the **Bahamas**, **Dubois** was destined to be a **scholar**
He showed through his intellect that **Blacks** could lead rather than always **follow**.
He felt that if **Black** advancement would be of any **length**
We would have to rely on our **"talented tenth"**.
His early antagonist, **Booker T. Washington**, told **Blacks** to **"cast down your buckets where you are"**
But **W. E. B.** stated that with the **"talented tenth"**, we should strive intellectually so we could go **far**.
In his Book, **"The Souls of Black Folks"** published in 1905, **Dubois** stated that the problem of the **20th Century** is the problem of the color **line**
For his accurate assertion, he was by both **black** and **white**, critically **maligned**.
In about __1900__ **Dubois** organized the first **Pan African Conference** for **African independence**
This move made him an international **nuisance**.
The lynching and the implementations of the separate but equal doctrine of the early **Twentieth Century**, led to the **Niagara Movement**
The inclusion of **Dr. Dubois** and **William Monroe Trotter** made the press call it a radical **element**.
The **Niagara Movement** led to the formation of the **NAACP**
This didn't set well with the **"powers that be"**.
Dr. Dubois became the first editor of the **NAACP Crisis Magazine**
His efforts would foster the **"Harlem Renaissance"** and help freedom to **ring**.
His early opposition to **Marcus Garvey and UNIA**, produced friction among **Blacks**
His support of **US** policy in **World War I** set him up for critical **"Uncle Tom"** attacks.
As the editor of the **Crisis Magazine, Dubois** became the most influential **Black man** on **Earth** His indept reporting on **Black** abuse, scholarship, and cultural endeavors far exceeded the country of his **birth**.

As the leader of the **NAACP, Dubois** became a tireless spokesman against **discrimination**

His opinions and writings provided **Blacks** all over the world with **inspiration.**

Carrying on **Pan_Africanism,** he became an international spokesman **too**

He influenced future **African Leaders,** like **Jomo Kenyetta** and **Kwame Nkhrumah** into what they were to **do.**

As a writer, he wrote numerous books on world **history**

Through research, he cleared up the **Black Man's** role and solved the **mystery.**

Dr. Dubois is regarded as the **20th Century's** greatest **mind**

This put the so-called **Black** ineptitude propagated by the power structure into a serious **bind.**

Dubois left **America** and became an international **man**

He was honored world-wide because of his uncompromising **stand.**

Countries from **China** to **Ghana** honored this great spokesman for our **race**

But among the **"powers that be"** in **America,** for his liberation views, he had fallen from **grace.**

He settled in **Ghana** with his old protege, **Kwame Nkhrumah** and everyone wondered **why**

So **Dubois** in his nineties, said he had gone to his ancestral home to **die.**

Dubois was working on an **African History Research** project when death **came**

The honor and tribute he was accorded gave testament to his world-wide **fame.**

Dubois's death came on the eve of the **"March on Washington"** which would highlight **Martin Luther King**

So **Dubois** through his death passed on mantle for others to help freedom to **ring.**

The Greatest Muhammed Ali

Cassius Clay entered our lives as the famous "Louisville Lip"
Headed straight to the world heavyweight boxing championship.
Starting out in Louisville, Cassius was the so-called protégé of a white policeman
Realizing that his training was inadequate, he slipped in for training under Louisville's foremost purgalist black hand.
Joining the US Olympic Team in 1960, Clay took Rome by storm
Capturing the gold metal showing his world championship form.
Coming back to Lousiville, Cassius was a hero to the Nation
But being Black in America made him subject to segregation.
Being so disgusted with discrimination, Cassius threw his gold metal in the river
He realized that he had a bigger goal and people to deliver.
Being sponsored by Louisville's white elite, he entered the professional ring
His immediate goal was a tomato red Cadillac that riches would bring.
The theatrics of "Gorgeous George" in Vegas, provided Cassius with the clue
That if he wanted packed arenas what he would have to do.
Becoming poetic and a master showman, Cassius captured the attention of the world around
And the rough edges were smoothed when Sugar Ray sent him Bundini Brown.
With Angelo Dundee and Bundini, Cassius conquered all competition in sight
While setting his bear traps for the ultimate Liston, heavyweight championship fight.
The private Cassius was introduced to the Nation of Islam in his search for identity
This would prove to be the move that he would find a natural affinity.
After the Victory over Liston, Cassius announced to the world that he was Muhammed Ali
Therefore, joining up with the worlds Islamic family.
As the most vocal and prettiest heavyweight champion, Ali brought pride in being Black

His association with **Malcolm X** and **Elijah Muhammed** brought him under **attack**.
He destroyed all the **White** and **Black** hopes in **sight**
So "the powers that be" decided to join the **fight**.
Ali was stripped of his title for refusing to go fight in **Viet Nam**
He decided to stand up as a man instead of being a flunky for **Uncle Sam**.
Muhammed Ali's stand brought him brotherhood with **Martin Luther King**
Because he agreed like **King** that we should have our own freedom before we help other people's freedom **ring**.
Ali's stand inspired youths for his and future **generations**
He was forever embedded as hero for the world's **Black Nation**.
Ali came back to reclaim his title from **George Foreman** in the "**Rumble in the Jungle**"
He defeated **Joe Frazier** in their third fight, "**The Thrilla in Manila**", as his personal life **unbungled**.
His domestic life seemed to take an edge off **Ali**
He lost to **Leon Spinks** in their **heavyweight melee**.
He regained his title for the third time and again became a bigger hero in this **land**
Because his stand for principle made him a great **Black Man**.
Muhammed Ali is the most popular and recognized man in the **world**
So may **God** continue to bless our **Special** "**Black Pearl**".

Of Schindler's List and Other Things

*Schindler's List was a great movie visualizing the vicious **Nazi attacks***
*With all the **Anti-Semitic** talk regarding **Minister Farrakhan**, I was
shocked that no soldiers had on **bowties** or were **black.***
*Through the destruction of the **Jewish** population is well documented,
Poles, Czechs, Russians, Gypsies, and even **Germans** were gassed in
abundance, **too***
***Nazism** under **Hitler,** showed that when it came to brutality, there was
nothing they wouldn't **do.***
***Jewish** leaders are determined to have everyone join them in the
condemnation of the **Jewish Holocaust***
*They seem to have forgotten that they were enthusiastic supporters of
segregation when the **white man** was the **boss***
*The **Royal Ice Cream Company, the home of the first sit-in,** was owned
by a **Jew,** who wasn't very **kind***
*When we asked for consideration and equality, he told all of us to **kiss
where the sun doesn't shine.***
*Most **Jewish** politicians of the old **South** sided with **whites** in their attacks
on **Blacks***
*Now they look for our support against so-called **Anti-Semitic attacks.***
*Great **Jewish** leaders like **Golden Frinks** was the **exception** and not the
rule*
*Because most **Jewish** people looked upon **blacks** as pawns and **fools.***
Jewish** leaders like **Oppenheimer,** control the **South African Gold Cartel
*The brutality shown on **blacks** there, came from the bowels of **hell.***
Jewish** leaders condemning others for comparing atrocities must be **wild
*Because whether you are **Jewish, Asian, Black, or Bosian,** you are all
God's child.*
*Hopefully, all mankind can come together in love as **brothers***
*And show through mutual suffering that we must look out for each **other.***

Gladys Knight

Gladys Knight entered our lives as the winner of the Ted Mack
Amateur Hour at the age of 5 years
Along with the Pips, she established herself with the million seller,
"Letter Full of Tears".
Gladys with her brother and cousins on a show blew the young
Temptations out
This was evidence of their growing future clout.
They came to Motown and their music was so fine
That they blew out all the groups with Motown's greatest hit "I Heard
It Through The Grapevine".
At Motown, Gladys blew out all the female competition in sight
So it was inevitable that she would have to return home to "Georgia at
Midnight".
Gladys and the Pips were the first at Motown to discover the talents of
"The Jackson Five"
This fictional story about Diana Ross's discovery of The Jackson Five
was nothing but a lot of jive.
Marvin Gaye's rendition, Gladys' greatest hit, "Heard It Through The
Grapevine" made her want to cry
So Gladys and the Pips left Motown when, "When Neither One Of
Them Wanted To Be The First To Say Goodbye".
Joining the Buddha Group, showed them how great creative control
could be
As this reflected later in their song, "You're The Best Thing That Ever
Happened To Me".
Gladys along with her new husband, produced and starred in the
movie "Pipe Dreams"
She further enchanted her cinematic credentials when she and the
Pips did Curtis Mayfield's Soundtrack for the movie "Claudine".
Gladys, after her nasty divorce, sought guidance from above
So she, along with her brother, Bubba, produced the hit HBO special,
"Sisters In The Name Of Love".
"That's What Friends are For" was produced by Gladys and friends,
Dionne Warwicke, Stevie Wonder and Elton John to help fight AIDS
Gladys showed that she was a participant in the humanitarian crusade.

Thank you Gladys for giving us your best
And for showing that if you have talent, God will give you the rest.

Today's Situation In Black

*Michael Jackson's exhorted settlement on charges of child **abuse***
*By a financially negligent father who let his children run **loose.***
*A stupid **Jesse Jackson** brought into the **Anti Semitic fray***
*By **Jewish Leaders** who will not vote for him any **way.***
*Jesse could denounce all of the prophets of the **Bible** and he would not get*
Jewish support
*Because they are as **Malcolm X** said, "**Instigators and Mediators**" looking*
*for people to **exploit.***
*The apparent **Black Unity** at the **Black Caucus** caused the dye to-be-set*
*So **Dr. Khalid's** statements were used to bring some dumb **Black** man into*
*their **net.***
*When the enemy of **Black Unity** comes along with his **advice***
*Intelligent people shake them off like **lice.***
*Come together in **Unity** and **Harmony** regardless of what people **say***
*Stop **Black on Black** violence and pool our resources and let **God** show us*
*the **way.***

Concerning Malcolm X

Malcolm X was a truly great and powerful **man**
who joined the **Nation of Islam** and made his **stand.**
With the guidance of the honorable **Elijah Muhammed, Malcolm** rose above all **strife**
to achieve what the Christians call "Everlasting Life."
Malcolm was given the name **Malik El Shabazz** by the **Messenger** and he took it to his grave
To show in life & death he would be no one's **slave.**
We brother's and sisters must realize the government is the master of camouflage
and will not hesitate to use it when there's a group they want to **dislodge.**
They hate black nationalism in general and the **Black Muslims** in **particular**
They want us to be imitation white men and take black from our **vernacular.**
Malcolm was assassinated not by anyone's **direction**
But because **Allah** had withdrawn his **protection.**
The honorable **Elijah Muhammed** loved **Malcolm** above all **others**
That's why **Malcolm** is still worshipped by the young **sisters** and **brothers.**
Allah touched **Malcolm** while he was in the **prison cell**
And he emerged from prison doing God's will and giving the White Man **hell**
Malcolm was referred to **by** writers as the **Biblical St. Paul**
A man on a sinful journey who responded to the **Maker's Call**
Minister Farrakhan was **Malcolm's Favorite Minister.**
To try to divide them is to do something **sinister.**
The Honorable Elijah Muhammed and his student **Malcolm X** are considered diamonds among **men**
When building a new **black man** and **black nation,** it is their work where we **begin.**

Black Moses
(Dr. Arthur George Gaston)

Dr. Arthur George Gaston came to Birmingham at the tender age of eight
He would become the most successful Black man ever in the so-called
bastion of hate.
He was taught the entrepreneurial spirit at an early age
He would use this knowledge to provide a service to the multitudes that he
engaged.
He started loaning money that led to his establishment of banks
He conquered discrimination by facing it head-on rather than going around
it's flanks.
Using the do-for-self-philosophy of his old friend, the honorable Elijah
Muhammad, Gaston built a vast business empire
he taught that we should do our best before our lives expire.
God was Dr. Gaston's guide and not the white man
This was his legacy for life if you really understand.
He established banks, funeral parlors, shopping centers and motels too
He taught by example that nothing is too big for a person with faith to do.
Gaston lived in an Alabama, when if a Black man brushed against a
White woman, he would be hung
He progressed despite the Black man being at the bottom of the economic
rung
Gaston was the foundation of the Civil rights Movement Climax, Birmingham
He provided shelter and bail money for Martin Luther King, Jr. and
others so that they could protest in dignity rather than being "on the lam".
Dr. Gaston's involvement in the Boys and Girls Clubs, brings Doc a lot of
pleasure
The kids get a chance to be with Black America's major treasure.
Thank you Dr. Gaston for being our shining light
And showing us that with God's help, everything will be all right.
God bless Dr. A. G. Gaston.

Dedicated to Ms. Bernadette Wiggins of the Birmingham Times.

God Is My Strength

*Whenever I feel **down***
*Like I'm alone & there's no one **around.***
God** is my **strength
*When the problems of life get too hard to **bear***
*When I wonder if I have a friend **anywhere.***
God** is my **strength
*When the days seem long & out of **control***
*When the nights are cold with no one to **hold.***
God** is my **strength
*When life is burdened by the concerns of **love***
*I look to my Lord in heaven **above.***
God** is my **strength
*Life is so full of constant ups & **downs***
*So God is my strength because hes always **around.***

Dr. Khalid Abdul Muhammed

*This is my tribute to my controversial brother who processes a **phd***
*Who is not satisfied until the **Black Man** becomes what **God** meant him to*
be.
Brother Khalid** became the victim of a so-called random **attack
*By a jealous brother working with cohorts determined to hold the **black***
*man **back**.*
Dr. Khalid** is dangerous because he has the attention of the **youth
*And tells them that freedom is more than just going to the voting **booth**.*
*Once the young hear **Khalid**, they are never the **same***
*Because **Khalid** is using the honorable **Elijah Muhammed's** teachings "Go*
after the young and the old will come through shame".
Khalid's** speech at **Kean College** put him on the world **stage
*His subsequent condemnation by **U.S. Congress** showed that as a leader,*
*his words had come of **age**.*
Khalid's** career in the **Nation of Islam** started as **Minister Farrakhan's
body guard
*His devotion and tenacity were the things that set him **apart**.*
Khalid's** rise to prominence was not without a government inspired **fall
*But **Khalid** rose from the ashes to become the **Nation of Islam's** spokesman*
*for one and **all**.*
Khalid's** words were hard because he was dealing with our hard **heads
*He was determined to get us out of our mental **beds**.*
*May **God** continue to bless you as you once again **rise***
*Because you in your controversial way are the **Black Man's prize**.*

You Can Depend On God

When your world has collapsed and everyone has put you **down**
You are never alone because your Lord is always **around.**
You can depend on God.
When your health is gone and you are in intensive **care**
When your only mobility is when the nurse brings you a wheel **chair.**
You can depend on God.
When your life seems to be going **nowhere**
Just hold on to the faith and put your problems in Gods **care.**
You can depend on God.
When the problems of the world seem to tear you **apart**
Keep your eyes on the word and God in your **heart.**
You can depend on God.

Justice American Style
(WACO & L.A.)

Whether in **L.A.** or **Waco** a travesty was **done**
by **officers of the Law** with the force of the **gun.**
*Though some will comment that **Koresh's followers** were led **astray***
*The stain of official murder will not go **away.***
*Some in the clergy feel that the road to salvation is paved free of **strife***
*We should study the words of **Martin Luther King Jr.**when he said "that a*
man
*Who is not willing to die in a righteous fight is not worthy of **life.**"*
*In the **Rodney King** case two officers were found guilty of violating a civil*
*rights **law***
*Despite the wanton brutality, this lack of justice really got under our **claw.***
*The constitution grants us the right to bear **arms***
*Why should the quantity sold to **Koresh** by gun stores set off bells of **alarms?***
*Whether it's **Baghdad, LA. or Waco***
*This brutality shows we have a long ways to **go.***

Thoughts

*Young people running around with their bodies full of **dope***
*The world in general has given up **hope.***
Politicians** stealing money to fester their **nest
*Kids have lost all thoughts of doing their **best.***
*Doctors killing unborn babies at the drop of a **hat***
*When young people kill we are surprised at **that.***
*Police systematically violating the law in order to make **arrests***
*Making the public's confidence in them grow considerably **less.***
Great Black men** defamed throughout the **nation
*By a society bent on Black **damnation.***
*Events in **Russia** supposedly have no hearing on Black **men***
*Yet **Boris Yetsin** contemplates his fate strolling around the park dedicated to*
*the **Black Alexander Pushkin.***
*Young **Black men** constantly filling up all the **jails***
*Neighborhoods all over the country becoming the **Black man's hell.***
Black** youths walking around town without **jobs
*In a world where the major preoccupation is finding someone to **rob.***
*We look for answers in our leaders of **today***
*But their own ineptitude shows that they have lost their **way.***
*The answer for our problems lies within **us***
*We must revolutionize ourselves and then in **God** put our **trust.***

Michael Jackson Under Attack

*Vicious accusations have **Michael Jackson** under **attack***
*But the real purpose is to hold the rise of the **Black man back.***
Michael** is being accused by a so-called responsible parent of child **abuse
*But that parent should be brought to the **carpet** for letting his child run **loose.***
Michael's** accusations should make successful **Blacks aware
*That **molestation** has become the nineties' "**Red Scare**".*
Michael** is under attack because of his money and **power
*Not because him and some kid were together in a **shower.***
*The vicious **L.A.P.D.** and **Federal Authorities** want to put **Michael**
under **control***
*Because a "**Black Conscious**" **Michael** is too frightening to **behold.***
*Neither **Mike Tyson**, **Michael Jordan**, nor **Michael Jackson** is guilty of
any **crime***
But they have to be stopped because the establishment doesn't want a
*"**Muhammed Ali**" type **black** man at this **time.***
*May **God** bless **Michael Jackson** because the attack on him is a attack on
us **all***
*Because with **God's** help this **Black man** will stay strong and never **fall.***

Redd Foxx

*It's ironic that as **Foxx** was into his latest TV run*
*That he would finally succumb to the "**Big One**".*
***Foxx's** albums were banned before the **2 Live Crew** were born*
*He was to comedy as **Satchmo** was to the horn.*
*A legacy of love and happiness is what **Foxx** brought to the world*
*He'll always be remembered as an authentic **Black Pearl***
He stood up as a man on the comedy scene
*Long before blacks started marching with **Martin Luther King**.*
***Redd's** career spanned almost 2 decades before Motown*
He had to rely on raunchy comedy because he could be no one's clown.
*He was on the **Chitlin Circuit** getting down*
*Years before anyone ever heard of **James Brown**.*
The acquaintances he met were with him to the end
*They could always say that **Foxx** was a real friend.*
***Slappy, Ester, Bubba** anb others were with **Rebb** in his early bays*
***Pryor, Murphy,** and other comedians were influenced by his very funny ways.*
***Foxx** used **Sanford and Son** as a vehicle to bring old friends to primetime*
*He wanted America to get a glimpse of the old **Apollo's Showtime**.*
***Sanford and Son** was a gigantic hit*
*Mostly because of **Fred's** walk and his quick wit.*
*His fights with **Ester** were something to behold*
He showed that black people had a story that had to be told.
His fights with Lamont were a lot of bunk
He gave class to the business of selling junk.
***Foxx's** legacy shined bright*
*when he starred with proteges **Pryor and Murphy in Harlem Nights**.*
*As a friend **Foxx** was always loyal*
*So it's ironic he ended his career starring as the man he was, **Royal***

God Is My Light

Looking out at the world **today**
I find it filled with darkness and I can't find my **way.**
But God is my light
Trying to figure out what to **do**
When the way of the world makes me feel **blue.**
God is my light
Life is sometimes full of darkness that engulfs us **all**
I call on my **Lord** *and he never lets me* **fall.**
God is my light
Going through the immense rigors of **life**
Sometimes I can't see my way clear of all the confusion and **strife.**
But God is my light
So when the difficulties comes and you want to make things **alright**
Just keep your head to the sky and **God will be your light.**

The Black Situation in Sports

The omission of **Heisman Trophy Winner, Charlie Ward** in the
NFL draft let blacks know for **certain**
That the position of quarterback in the NFL is still the **"White man's
burden"**.
The acclaim and adulation accorded **Charlie Ward** made the NFL
show its racist **face**
And showed that if you are **black** and playing **quarterback,** we have to
put you in your **place.**
Ignorant sports columnists compare **Charlie Ward** to **Doug Flutie**
But **Blacks** who played| quarterback are there on ability and not
because they are a **cutie.**
If **Ward** had won the **Heisman** playing the position to his left or **right**
His selection as the number one pick would have been **airtight.**
Ward decided that instead of being a follower, it was his time to **lead**
Because for **black youth,** he felt a pressing **need.**
Charlie, may God bless you as you weather this **pain**
And let you know that your effort on behalf of **black manhood** is not
in **vain.**

The Soul of Babyface

*As a composer, **Babyface** again answered the **bell***
*With his latest composition, **Whitney Houston's "Waiting To Exhale".***
*Since getting married, **Babyface** works with a seemingly all **white band***
*Putting down **L. A.**, and working with **Jon B.**, he looks like he has joined*
*the **Ku Klux Klan.***
*When you were broke and trying to make it, you joined up with **L. A.***
*But now that you have had success, you dropped him to go your own **way.***
*As brothers, even through we do solo projects, we should always work **together***
*Because when hard times come, we are all birds of the same **feather.***
Babyface,** when it comes to music, you are definitely the **best
*With hits with **Madonna, Tevin Campbell** and **Boyz to Men**, you have to*
*remember that unity is the key to your **success.***
*From **"I'll Make Love To You"** to **"Water Runs Dry",***
*We are all **"Digging On You"** and I guess you know **"Why".***
*You are the **"King of love ballards"** and songs from the **heart***
*So these are the things that really set you **apart.***
*Remember who you are and don't fall for the old **Hollywood** game*
*Of being duped by people who only want you because you are a **name.***
*May **God** bless you as you let the melodies **flow***
*Probucing new songs like **"Red Light Special"**, and **"Let it Blow".***

Jackie Wilson

*Jackie Wilson started his career as a **Golden Glove Purgalist** for one of Detroit's top match **makers***
*But the street smarts in him made him the leader of **Detroit's** notorious "**Shakers**".*
*His friendship with fellow boxer, **Berry Gordy**, would prove invaluable later in his singing **career***
*He told how it is "**To Be Loved**" for all to **hear**.*
*When it came to love, **Jackie** was on **top***
*With the release of the monster hit "**lonely Tear Drops**".*
*Jackie became a sex symbol when **Blacks** only job was to carry a **mop***
*He taught his smooth moves to a young **Elvis Presley** and helped him go over the **top**.*
*Jackie entered the sixties with his career on **fire***
*Despite using coke, he had us all going "**Higher and Higher**".*
*He was idolized by **Millions** all over the **world***
*But his destiny was sealed when he took up with the "**Girl**" (**Cocaine**).*
*Crooked management and his addiction made **Jackie** old before his **time***
*But this former student of **Clyde McPhatter** and **Billy Ward**, music still blows the **mind**.*
*While performing on **Dick Clark's Oldie Show**, **Jackie** suffered a **stroke***
*Despite his years at the top, this superstar was financially **broke**.*
*Jackie would remain comatose for the rest of his **life***
*But his influence on **Motown** and other future balladeers is apparent even though his own direction was full of turbulence and **strife**.*
*Though **Jackie** wasn't perfect, he always did his **best***
*He went through uncharted waters to make a way for future singers like **Michael Jackson** and all the **rest**.*
***God** bless **Jackie Wilson**.*

Elvis

(Elvis Presley, "The King of Rock & Roll")

Elvis was born in **Tupelo, Mississippi** as one of a **twin**
He would shake up the world before his life would **end.**
"That's Alright Mama" would be his first **hit**
It would be the spark for his career to be **lit.**
Elvis decided he didn't like to live his life on the **hog**
So he went out and recorded the monster hit, **"Hounddog".**
His success was still not a **lock**
Until he came up with the **"Jailhouse Rock".**
The death of his **Mother** hit him especially **hard**
Because he thought they would always be together and never **apart.**
His marriage to **Pricilla** gave him a degree of peace in his **life**
And the birth of a daughter helped rid him of confusion and **strife.**
Movies, along with singing made him the most popular entertainer on **earth**
His influence extended far beyond the country of his **birth.**
Gospel music and the **Blues** were his musical **foundation**
He took them to the far ends of the world and **nation.**
Although he was a **Master Karate** expert, some **Blacks** considered **Elvis**
as **racist** as could be But he dispelled that notion when he gave a **$20,000**
boxing robe to his friend, **Muhammad Ali** His generosity to fans, both
Black and White, showed a heart of **gold**
After him they indeed threw away the **mold.**
Reckless living eventually led to a deterioration of his **health**
An assortment of different drugs contributed heavily to his **death.**
Elvis, in life and death, captured **America's imagination**
His multitude of fans will always remember him for his humbleness and
dedication.

Melvin (Blue) Franklin
of The Temptations

*Melvin's deep bass voice always gave the **Tempts** a solid **foundation***
*And he lived and died always a **Temptation**.*
*Along with **Otis Williams**, he never left the **group***
*His bass voice influenced future singers as they entered the musical **loop**.*
*Blue's tribute to **Paul Robeson** in the "**Mellow Mood**" album was his*
*rendition of "**Old Man River**"*
*As spokesman for the group with his booming voice, he never failed to **deliver**.*
*For us in the sixties, **Melvin's** voice gave us strength when we as a people*
*were **weak***
*He provided a role model for us when our leaders were **meek**.*
*As an original **Temptation**, **Melvin's** bass was the springboard for the*
***David Ruffin** and **Eddie Kendricks** sound*
*He had the deepest voice anywhere to be **found**.*
David, Eddie, Paul, Otis** and **Melvin** meant the world to **us
*They took **Black** people from **the outhouse to the front of the bus**.*
Melvin and Otis** kept the faith despite changes in **personnel
*When we needed them, they answered the **bell**.*
*"**I truly, truly believe**" that though you have left, we are never **alone***
*Because through your records, the soul goes **on**.*
*Long live **Melvin Franklin**.*

Why We March
(*The Million Man March*)

*Minister Farrakhan has convened a **Million Man March** on*
Washington, D.C.
*To let the world know that we are **strong men** and not the **buffoons** they*
*picture us to **be**.*
*This **march** for our future will set the **tone***
*Because all other marches were **in Washington, rather than on.***
We march for freedom, we march for reparations, and we march for our
*rights as a **man***
*But above all, we march for our own free **Black homeland.***
The Million Man March** will show the **Black man** in a new **light
We will let the world know that for freedom and justice, we are willing to
fight.
*We march also for self-empowerment and self-respect, **too***
*We march because its time for the world to give us our **due.***
We will tell the world that you can address us only through our leader,
Minister Farrakhan
*We will no longer be all **Black flunkies** to be used as **pawns.***
*Our women will respect us more after the **March***
*They will realize that the **Black man** now has the right **starch.***
So March On Black Man** and be the best that you can **be
*And show the world the **men of God** that it is waiting to **see.***

Consultant: Dr. Fahim A. Knight, the world's most controversial
author

Reflections on Oklahoma City

*The tragic bombing in **Oklahoma City** gave us all a wake up **call***
*the **mighty US government** has begun to **fall**.*
***Elijah Muhammad** said, "Study what is happening overseas because the*
*one thing you see happening will one day be at your **door***
So it's time for us to be realistic rather than just panicking and falling on the
floor.
Our beautiful black sisters and brothers were killed and maimed by this
*dastardly **attack***
*by supposedly white nationalist, who for **Waco,** wanted to get the*
*government **back.***
*I wonder whether these are the real culprits or just 1995's version of **Lee***
Harvey Oswald.
Patseys** who are primed and implicated to always take the **fall
*The **Bible** pronounces implicitly as a law "that you reap what you **sew."***
With the wanton destruction of innocents in Iraq and other places by the
US government,** the bombing was the only part of God's **flow.
*To get peace we must love others as we love **ourself***
*or we will experience death and destruction and peace will be on the **self.***
*The bombing of black churches and homes in the south has to be **atoned***
By the supreme justice that was here before us and will be here long after
*we're **gone.***
*Make your belief in **God first***
*If peace and harmony is what you **thirst.***
God** bless the people of **Oklahoma City.

The World In Black IV

*We now have **Quibilah Shabazz** charged with plotting **Minister**
Farrakharis assassination*
*By a evil government bent on black leadership **elimination** .*
*Her mother, **Betty** is to blame for her unwarranted condemnation of*
*Malcolm X's protégé, **Minister Farrakhan** by letting her lips run **loose***
*So her daughter became the victim of **Malcolm's prophetic words,***
*"**Chickens come home to roost**". This whole episode is attempt by the*
*government to cause divisions among **blacks***
*Because **all intelligent people** know that only government agencies could*
*carry out such a dastardly **attack**.*
*So many of our **Orthodox Islamic brothers** don't realize that it was the*
*honorable **Elijah Muhammed** who found us a "**shine or boy**" and made us*
*a **man***
*Before our **Middle Eastern brothers** would ever extend us a helping **hand**.*
President Clinton** sending **$20 Billion** to the government of **Mexico
*At the same time, telling our **cash-starved cities** where they can **go**.*
*The **O.J. Simpson** case has put a lot of **black stars into denial***
*That all **interracial marriages** is today on **trial**.*
***God** help the **13 year old brother in North Carolina** who for his alleged*
*assault on a **white woman,** was given life plus **fifteen***
*Despite all this talk of **racial tolerance,** some **whites** in their hearts are still*
*very **mean**.*
*May **God** continue to bless us as we carry **on***
*Because despite all our troudles, we are never **alone**.*

Love

A lot of people live their lives looking to heaven **above**
While the peace they want comes only through **love.**
The majority of people only experience lovers so-called physical **aspect**
So when the true love comes along, they don't know what to **expect.**
The soul, which is the essence of the human being, provides the true **love**
It is controlled not by **earthly pleasures,** but by **God above.**
True love has a calming effect on the **soul**
It gives you a peace that you can't buy with all the world's **gold.**
True love gives you a wholesome **life**
It rids your mind of all the suffering and **strife.**
It gives you a contentment only your soul can **feel**
Because in your heart you know that only love is **real.**
So for those of you who have been educated in love's so-called **rules**
Love has more to it than just a misunderstanding between two **fools.**

God Is My Source

*As I go through the world and see friends who are **down***
*I hold on to the knowledge that my **Lord** is always **around**.*
God is my Source
*I go through this life as peaceful as can **be***
*Because I know that **God's light** is shining down on **me**.*
God is my Source
*While the problems of life seem to get my peers **down***
If you are in the faith,
***God** will take you off **life's merry go round**.*
God is my Source
*Sometimes contentment is a hard thing to **find***
But if you choose the righteous path,
God** will bring peace to your **mind
God is my Source
*So friends in life, you have freedom of **choice***
*If you want happiness, make **God your Source**.*

Black Extermination 1995

*The **state and federal government** have become the leading warehouser of **black men***
*It seems that everything **Black** people do is a state **sin.***
Drug dealers** are viewed as perpetuators of **hate
*While **gun dealers** are supposedly servants of the **state.***
*The **neo-slavery** against the **black man** is not by accident but by **design***
*A prominent **black man** not under investigation by some agency is hard to find.*
Young black men** using obtainable weapons of mass destruction, are given **life
*To make sure they are not able to have a family and a **wife.***
*Positive programs that help **black youth** are being **ridiculed***
*By a **hypocritical government** who look upon **blacks** as pawns and **fools.***
Prisons** being expanded as part of a concerted and evil **strategy
*To foster in a new holocaust in this new **black tragedy.***
Government agencies** deliberately allowing **guns and drugs to flood our streets
*To make sure that those not incarcerated lie dead under the **sheets.***
*We as **black men** need total control of our own **neighborhoods***
*So we can rid our people of the **notorious Boyz in the Hood.***
*Our people need to be redeemed, not just packed in **jail***
*Because this further perpetuates the **black man's hell.***
Discipline** for our youth and adults is the answer for **all
*Give up this reckless living and pool our resources, so that despite all attempts, the **black man will never again fall.***

Black Justice II
(Michael Jackson)

The whole world was shocked by Michael Jackson's official
dehumanization
This brought back the truth about the country that is supposedly the world's
leading civilization.
As a personality and entertainer, Michael is on top
Since there's no white person that can take his place, "the powers that be"
decided he must drop.
The strip search and photographs went far beyond reason
But in this time, the attacks on Black manhood is in vogue this season.
No human being is entitled to this type of examination
But it exposed to the world what Black Slaves experienced everyday in this
God-forsaken nation. The examination of Black people's private parts on
the auction block was part of the dehumanization process
We were branded like cattle, but thought of less.
All Blacks during slavery, carried whip marks on their backs
As evidence of the vicious humiliating racist attacks.
God let Michael suffer his abuse so that Blacks would not forget
That for freedom, although we have made progress, we are not there yet.

Hell In The Streets

*People being murdered all over the streets of **America***
*By gun-toting thugs caring out mass **hysteria**.*
*Politicians in the pocket of **Arab Oil Sheiks***
*Whose financial support fuels these **drug freaks**.*
*Mothers and children getting caught up in the **drug trade***
*While our leaders are talking loud and getting **paid**.*
*A Hypocritical **Bill Clinton** likening himself to **Martin Luther King***
*While at the same time wanting to smash starving **Iraqi** children to*
***smithereens**.*
International violence has a definite effect on whats happening in
Americans streets
As long as we continue to perpetrate violence abroad, communities all over
*the country, will be littered with murdered bodies covered by **sheets**.*
*The answer for us lies in righteous **living***
*We must stop the stealing and do more **giving**.*
*Only **God** in his infinite wisdom, can release us from this **hell***
So lets come together in love and harmony so we can go forward and never
***fail**.*

If You Left

*If you left, what would I **do***
*Because in my life you are the **glue***
*If you left, what would happen to **me***
*Because you gave me love for all to **see***
*If you left, how would I **live***
*Because you gave me all that you could **give***
*If you left, would I be **wrong***
*To give up on life and refuse to be **strong**.*
*If you left, what would happen to your **friends***
*That you swore to be with to the very **end***
*If you left, it would really break my **heart***
*Because I thought we'd never be **apart**.*
*If you leave, I know you would be with **God***
*With your wings in heaven and always in my **heart**.*

Al Green
(Crown Prince of Soul)

Al Green entered our lives by telling us what to do
When Your baby is being funky and "I Can't Get Next To You".
He told us that before you get crazy on the phone
Just hold her near and tell her "I'm Tired Of Being Alone".
With Willie Mitchell and Al Jackson, he told lovers that they were birds
of the same feather
So regardless of our adversity, "Let's Stay Together".
Al kept us going when we didn't know what to do
By saying that despite everything, "I'm Still In Love With You".
Despite being on top, Rhythm and Blues was not where he was meant to be
So God sent him a message in his hit, "You Ought To Be With Me".
Al had "hot grits" thrown onto his backside
By a deranged girlfriend, who later comitted suicide.
This traumatic episode made God's message to Al very clear
So he became a preacher and held God near.
Al started singing the gospel and praising the Lord
He brought millions to God and filling up the void.
Being saved, Al again could sing the blues
With a new spirit and spreading the good news.
Thank you Reverend Al for being the prince of soul
Because with God's guidance, you are worth your weight in gold.

Faith Is The Key

*Sometimes the problems of life seem as bad as can **be***
*So stay in the spirit because **faith** is the **key.***
*People who succeed in life are no better than **you***
*They keep on keeping on because **faith is the glue.***
Faith** is the thing that kept **D.C. mayoral candidate, Marion Barry
*afloat after all his friends had put him **down***
*He knew in his heart that his **Lord** is always **around.***
Faith** is the motivating force that makes love go **strong
*It keeps you going when the whole world thinks you're **wrong.***
God** is the force that keeps **faith alive
*It will keep you going no matter what you **strive.***
*So take this life, come what **may***
*Because **faith** is the **key** to **your salvation today.***

Dedicated to my mother, Mrs. Louise Dixon and my grandmother, the late Mrs. Mabel Lyon.

LaVergne, TN USA
24 November 2009
165143LV00002B/53/P